Human and Divine 2000 Years of Indian Sculpture

BALRAJ KHANNA *and* GEORGE MICHELL

D1383584

National Touring Exhibitions

sbc

Published on the occasion of
Human and Divine: 2000 Years of Indian Sculpture,
a National Touring Exhibition organized by
the Hayward Gallery, London, for
the Arts Council of England

EXHIBITION TOUR:
The New Art Gallery, Walsall
22 July – 17 September 2000

Sainsbury Centre for Visual Arts, Norwich
30 September – 10 December 2000

City Art Gallery, Southampton
12 January – 25 March 2001

Exhibition selected by Balraj Khanna and George Michell
Exhibition organized by Roger Malbert,
assisted by Miranda Stacey

Glossary and chronology compiled by Helen Luckett
Map by Graham Reed
Catalogue designed by Peter Campbell
Printed in England by P.J. Print

Front cover: **Chunda, a Jain yakshi**, central India
(Madhya Pradesh), 10th century, *The British Museum, London*
(cat. 62) (detail)

Back cover: **Krishna dancing on the serpent Kaliya**, southern
India (Tamil Nadu), Vijayanagara period, 16th-17th century,
Victoria & Albert Museum, London (cat. 40)

Inside front cover: **Corbelled dome with figural brackets**,
Dilwara Temple, Mount Abu, Rajasthan, 11th century

Inside back cover: **Gods and mithunas**, Khandariya Mahadeva
Temple, Khajurahu, Madhya Pradesh, 11th century

Published by Hayward Gallery Publishing,
London SE1 8XX

© The South Bank Centre 2000
© Essays, the authors 2000
Photographs © Nicola Levinsky 2000 (cats. 1, 11, 22, 27,
28, 29, 31, 35, 55), © University of Aberdeen 2000
(cats. 8, 19, 21)

The publisher has made every effort to contact all copyright
holders. If proper acknowledgement has not been made, we
ask copyright holders to contact the publisher.

ISBN 1-85332-210-5

All rights reserved. No part of this publication may be
produced, stored in a retrieval system or transmitted in
any form or by any means without the prior permission
in writing of the publisher.

This catalogue is not intended to be used for authentication
or related purposes. The South Bank Board accepts no
liability for any errors or omissions which the catalogue
may inadvertently contain.

This publication is distributed in North and South America
and Canada by the University of California Press,
2120 Berkeley Way, Berkeley, California 94720.

Hayward Gallery Publishing titles are distributed outside
North and South America and Canada by Cornerhouse
Publications, 70 Oxford Street, Manchester M1 5NH
(tel. 0161 200 1503; fax. 0161 237 1504).

Note

Diacritical marks have not been used so as to make
this publication as accessible as possible to the
general reader.

All dates are AD unless stated otherwise.

Contents

Preface

The wealth of Indian art in British public and private collections is celebrated most conspicuously in the fine displays in the British Museum's Hotung Gallery, the Victoria & Albert Museum's Nehru Gallery and Edinburgh's Royal Museum of Scotland. These and other museum collections, smaller but of equal quality, are a vital resource for the appreciation and understanding of the art of one of the world's great civilizations. *Human and Divine* includes a significant number of masterpieces of Indian figural sculpture from all three museums mentioned above, and it is their generosity – and that of our other lenders – that has enabled us to assemble and to tour an exhibition of such high quality.

When Balraj Khanna suggested to the Hayward Gallery that we organize a National Touring Exhibition of Indian sculpture drawn from British collections, it was with the aim of showing them, as far as possible, in the way that modern sculpture is shown, emphasizing their qualities as works of art. Each of the three venues on the tour offers a distinct but stimulating and appropriate context for an exhibition of this kind. We are delighted that the show is opening at The New Art Gallery Walsall, whose beautifully-proportioned spaces provide a sympathetic setting. The gallery's permanent collection contains a large number of works by the sculptor Sir Jacob Epstein, one of this century's outstanding carvers in stone. The Sainsbury Centre for the Visual Arts, at the University of East Anglia, contains a superb collection of non-Western and Western modernist art, suggestively juxtaposed, and this offers an opportunity to consider ancient Indian sculpture in a contemporary aesthetic context; so too does the collection of recent British sculpture at Southampton City Art Gallery, the final venue of the tour.

The exhibition has been selected by Balraj Khanna and Dr George Michell. Balraj Khanna has previously curated two memorable and successful shows for National Touring Exhibitions: *Kalighat: Indian Popular Painting, 1800-1930* and *Krishna: the Divine Lover*. Dr Michell, archaeologist and writer, was involved in the selection of sculptures for the Hayward Gallery's exhibition *In the Image of Man – The Indian Perception of the Universe through 2000 years of Painting and Sculpture* in 1982, and was the curator of *Living Wood: Sculptural Traditions of Southern India* for the Whitechapel Art Gallery in 1992. We thank them both for the vital knowledge and dedication that they have brought to this project, and for their insightful essays in this catalogue.

We have benefited from the research undertaken by Dr Kalpana Tadikonda into British public collections of Indian art and artefacts. Among our lenders, we should like to thank especially Dr Deborah Swallow, John Guy and Nick Barnard of the Victoria & Albert Museum, John Knox, Richard Blurton and Steve Drury-Thurgood of the British Museum, Dr Ulrike Al-Khamiz, Lynn Wall and Rosalyn Clancey of National Museums of Scotland, Neil Curtis of the Marischal Museum, Aberdeen, Paul Spencer-Longhurst of the Barber Institute of Fine Art, Birmingham, Lindy Brewster of the Oriental Museum, Durham, Sally Dummer and David Jones of Ipswich Museum, Kate Cook of John Eskenazi Ltd, Gordon Reece and Fabio Rossi of Rossi & Rossi Gallery, and those lenders who wish to remain anonymous.

We also extend our thanks to our colleagues at the exhibition's venues, who have embraced the challenges of this complex exhibition with enthusiasm; in particular Peter Jenkinson and Deborah Robinson of The New Art Gallery Walsall, Nicola Johnson, Amanda Daley and Don Sale of the Sainsbury Centre for the Visual Arts, and Godfrey Worsdale of Southampton City Art Gallery.

Among those who have given invaluable help and advice, we thank John Marr, Yvonne McFarlane, Alnoor Mitha, Raj Pal, Andrew Topsfield and Louise Tythacott. We are similarly grateful to Melanie Rolfe, the sculptor conservator who has advised us on the handling and display of work, and to Peter Campbell for his elegant and sensitive design of this catalogue.

As ever, I am grateful to my colleagues at the Hayward Gallery who have helped to realize this National Touring Exhibition project so magnificently – in particular Roger Malbert, the Hayward's Senior Curator, National Touring Exhibitions, and Assistant Exhibition Organiser, Miranda Stacey, who have worked tirelessly to bring this superb collection of work together and who have dealt resourcefully with its many demands. Helen Luckett, the Hayward's Education Programmer, has produced the glossary and chronology for this catalogue and the educational material available in the exhibition. Mark King and the Hayward's installation and transport teams have, as ever, handled the technical requirements of the exhibition with consummate skill.

Susan Ferleger Brades
Director, Hayward Gallery

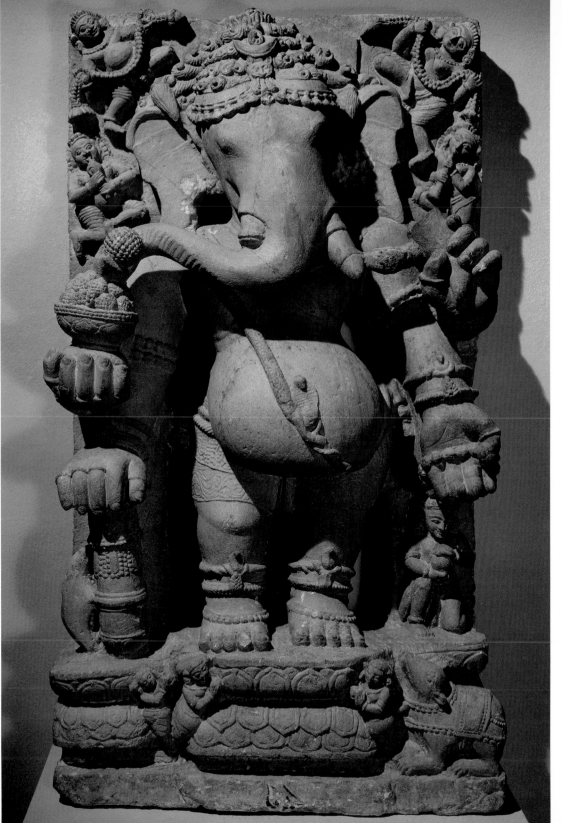

44
Ganesha
central India (Madhya Pradesh)
10th–11th century
sandstone

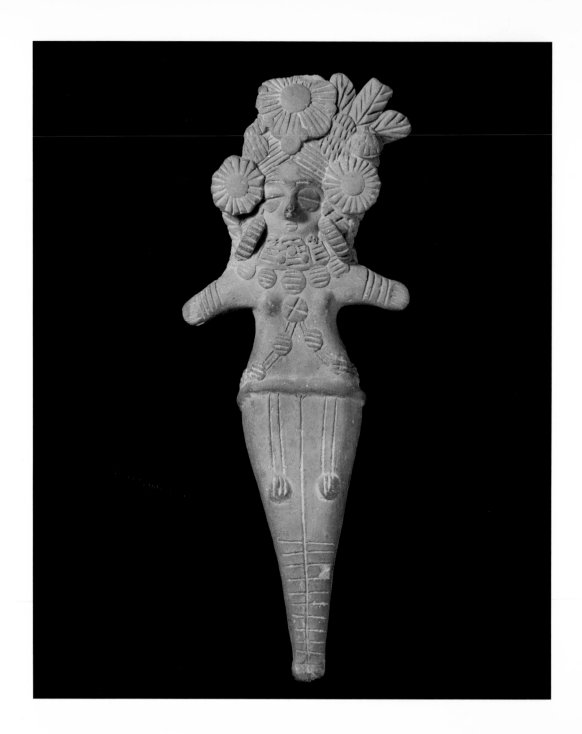

2
'Mother goddess'
northern Pakistan
2nd century BC
terracotta

Communicating with the Gods

This book gives us a glimpse of the great tradition of Indian sculpture and valuable insight into the inspiration behind it. Based on spiritual ideals and aesthetic principles unique to India, her sculpture developed in answer to the intensely-felt religious needs of the people. It became, and is, an integral part of everyday life, rather than remaining a remote art-for-art's-sake activity.

Indian sculpture was made for a specific and living purpose – to worship God and to adorn places of worship. It was fashioned by the people for the people in a fluid social context, in which the egos of its makers merged with the expectations of its beholders. Traditionally, the authorship of a work of art was less important than its creation, which explains why much of it is anonymous – from the earliest extant literature to the sculpture of the seventeenth century. In this way, whatever their religion, Indians have always revered these creations as embodiments of the Universal, reaching out to them, free from the distraction of specified human involvement.

Indian art is ever trying to realize something of the Universal, Eternal and Infinite, something extremely subtle and of the *highest* beauty. Indian art is both idealistic and transcendental, yet it nonetheless allows ordinary people to relate to it. Indians view and treat their gods as celestial beings living among them – devotees bring them offerings of food and flowers, give them a ritual bath and a daily change of clothes, put them to bed when darkness falls and wake them

up at the crack of dawn. Indian sculpture is best understood in context for a full appreciation of what in essence is a means of communicating with the gods. Even when it displays qualities of the highest aesthetic achievement, the principle remains the same – to enshrine the divine presence. Man is directly linked to the Universal in whom all things are embodied and from whom all things emanate. God is *Paramatma*, the Supreme Soul; man, *jivatma*, the individual soul. A merger of *jivatma* with *Paramatma* is the ultimate aim of human existence as taught by Hinduism, through yoga, meditation or other means. The Hindus call this *moksha*, freedom from the endless cycle of birth and re-birth. For Buddhists and Jains, such release from re-birth – a burden assumed by all three religions – is *nirvana* (snuffing out), when the soul ceases to exist.

Throughout India's long history, the tradition of image-making has flourished at many levels – from the most elementary and rudimentary form of a mother goddess from the lost Indus Valley civilization circa 3000 BC and a more elaborate one from the third century BC, to the most sophisticated, stunningly beautiful and complex products of medieval India. On an ambitious scale, masterpieces in stone, marble, metal or wood adorn great temples where multitudes daily arrive for a *darshan*, face-to-face eye contact with a famous benefit-bestowing deity – a moment of immense importance. On a humbler level, simple and minuscule representations of the gods in clay, often accompanied by a handful of marigolds and a curl of smoke from a stick of incense burning close by, form a private shrine in a home. Whether grand or modest, Indian sculpture speaks of a remarkably consistent and sustained visualization of the transcendent in an abundant variety of images, personifying the innumerable aspects of an essentially unknowable and formless God.

In order that God's multifarious manifestations could be brought within human understanding, it became necessary early on in Indian history to visualize him as having human form, traits, virtues and some frailties too, and to give him names and titles. At first, during the long Vedic period (1500-1000 BC), this was achieved through words only: the hymns of the *Vedas*. No examples of the art of these times have survived. In later epochs, the lives and teachings of the Buddha (563-483 BC), along with those of Mahavira (540- 468), the founder of

Jainism, and the growing Hindu mythology, especially India's two major epics, *Ramayana* and *Mahabharata*, provided a virtual *carte blanche* for visual invention, resulting in one of the world's greatest traditions of art and architecture.

Aesthetics of Indian Art

Well-defined aesthetic ideas were assembled in a fourth century AD treatise on dramaturgy, entitled *Natyashastra* and ascribed to Bharata, containing guidelines for *natya* (drama), dance and music. This aesthetic theory was applicable to other arts as well, especially sculpture which has a natural affinity with dance. The *Natyashastra* crystallized Indian aesthetic thought, laying down rules for creative expression which had to be followed strictly. Every work was required in an unselfconscious way to exude a certain special flavour or *rasa* – a Sanskrit word in daily use in contemporary India meaning juice (like that of a fruit) – to arouse in the beholder the desired response, *bhava*. Bharata's book carried a list and commentaries on most notable *rasas* which was extended by later thinkers, but the following five with their linking *bhavas* have been of particular relevance to the development of Indian sculpture:

> *shringara* (the delightful or the erotic) – *rati* (love)
> *rudra* (the furious) – *krodha* (anger)
> *bhayanka* (the terrible, frightening) – *bhaya* (fear)
> *vira* (the heroic or the valiant) – *utsaha* (energy)
> *shanta* (the peaceful) – *shama* (tranquility)

Historically, the *shringara rasa* has been the most popular, reflecting the innate need of the Indian psyche to celebrate the gift of life, so lavishly and poetically illustrated by Indian sculpture, as well as literature, dance and painting.

A later text, the anonymous *Shilpishastra*, gave instructions for sculptors concerning the practicalities of their craft. It showed them how best to achieve a balance between concave and convex forms, between positive and negative shapes. Similarly, *Shilpishastra* offered guidance on the right translation of body language into expressive movement. It emphasized certain

11 *(above and detail right)*
Two surasundaris
central India (Madhya Pradesh)
Chandella period
10th–11th century
sandstone

mudras (gestures made by hands and fingers) and figure groupings – inspired by dance and drama – to convey the desired dramatic effect. Facial expression was considered of the utmost importance. Godly figures had to radiate serenity and total calm, a hallmark of Indian sculpture, achievable only by sculptors who themselves were calm. Thus, the gods are always looking beyond human life – we can never meet their gaze because it is always focused inward, the reservoir of tranquility.

Verisimilitude to life was not the sculptor's concern. What he was expected to depict was a certain chosen *rasa* that a figure or a group of figures was to excite. Also, anatomical detail, such as musculature, was not observed accurately in Indian sculpture, the transcendental aspect of the figure being more important than its perceptible properties. When a *yogi* (*yoga* means 'yoking', i.e. the mind to God) sat down to meditate, he took a deep breath – *prana* (the breath of life) – filling his chest and then exhaling slowly. Performed repeatedly, this exercise intensified the concentration of the mind, making the yoking of it to the source of *prana*, God, more easily achievable. It was the sculptor's aim to capture the moment when a *yogi*, say a Jain divinity, sat in the upright lotus position, his waist narrow and his chest slightly expanded because it held the *prana*. The sculptor could do this because he himself had experienced that moment and therefore knew how it felt to be in that state when the *prana* was drawn in.

Sculpture in India has a very different meaning to that of the West. Traditionally, it did not have a civic role to play, nor was it created to satisfy aesthetic curiosity. That it is now on view in museums all over India – and enjoyed, too – was largely due to a British convention, established in the nineteenth century during the heyday of the Raj. Indian sculpture has always occupied a special, private place within people's hearts. It radiates reassurance, compassion and love, fulfilling the inner need to be in tune with a higher power. Most Indians are well-versed in the elaborate *Who's Who* of their religion. Hindus know what every god and goddess personifies and what *rasa* he or she emanates in whichever form they are presented in sculpture or painting. Some they know so well that they can communicate with them on a person-to-person basis, as with a close friend. And, typically, in devotional India, they know in their hearts that this is not a one-sided relationship.

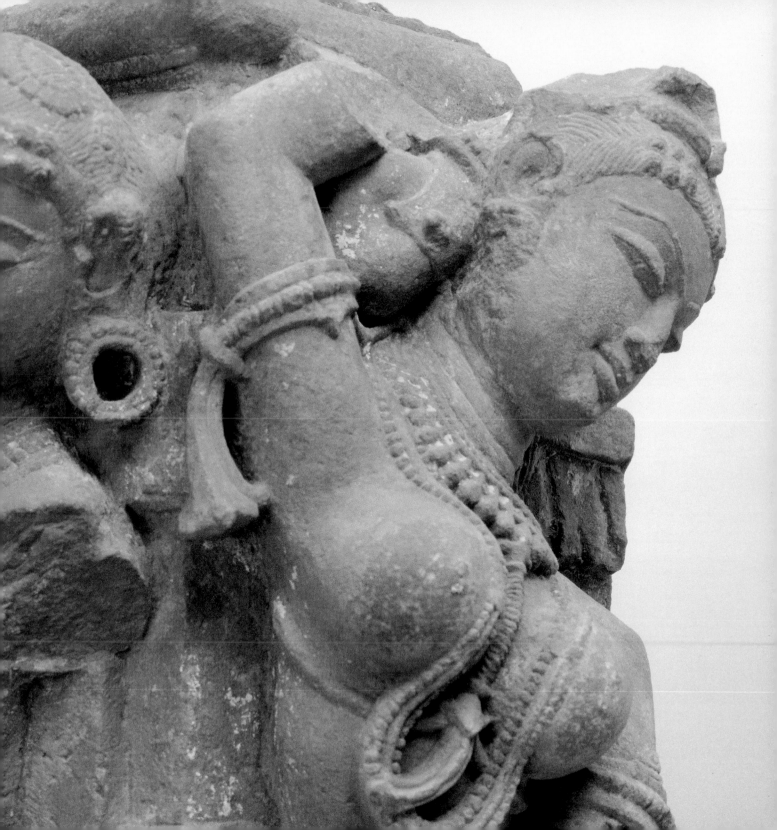

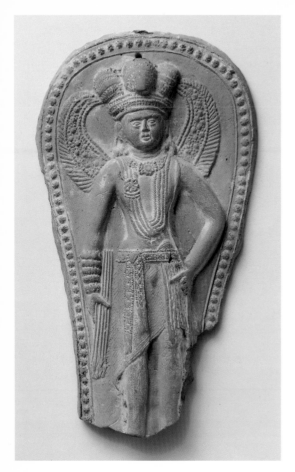

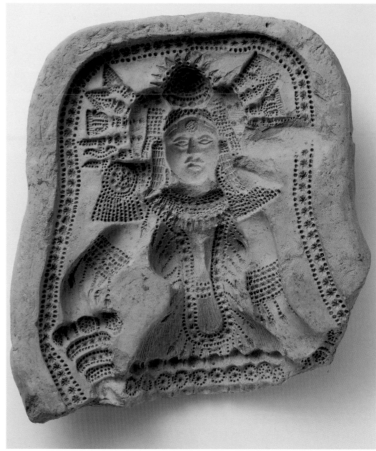

54 (above left)
Winged god
eastern India (West Bengal)
Shunga period, 2nd–1st century BC
terracotta

4 (above right)
Mould with yakshi
eastern India (West Bengal)
Shunga period, 2nd–1st century BC
terracotta

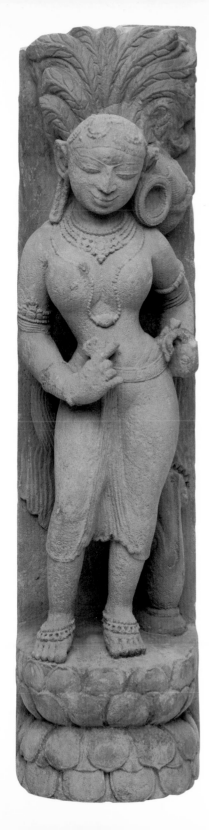

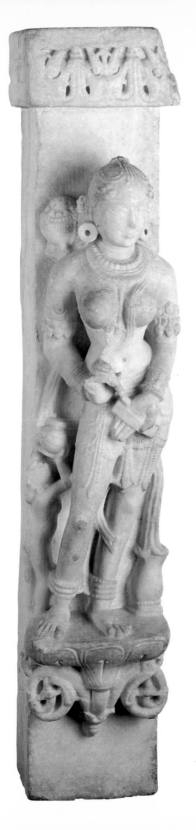

13 (far left)
Maiden
eastern India (Orissa)
Ganga period
12th–13th century
sandstone

12 (near left)
Surasundari
western India (Rajasthan)
11th century
marble

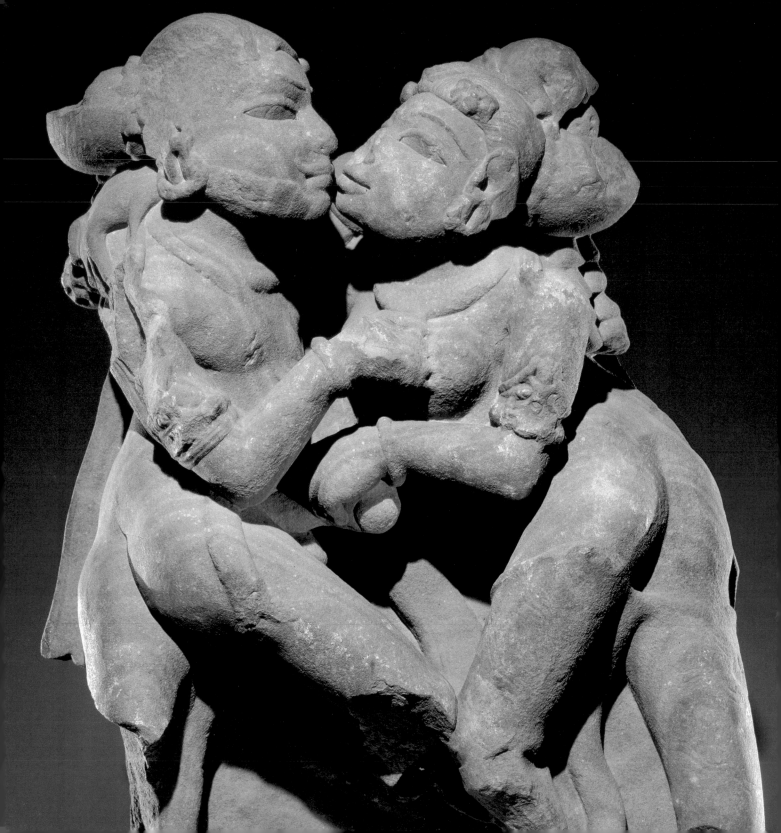

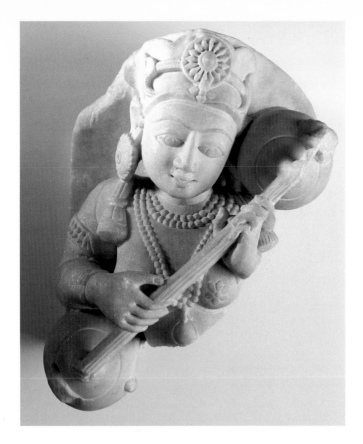

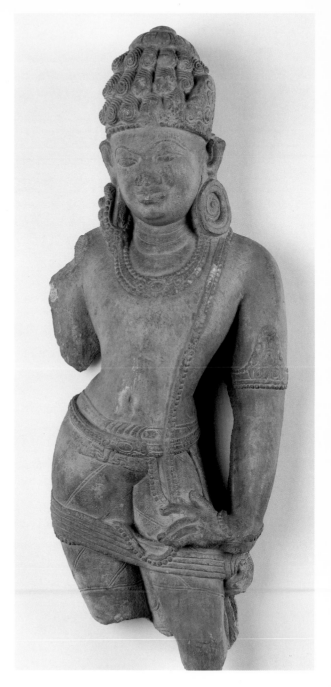

7 (above)
The goddess Sarasvati playing a vina
western India (Rajasthan?)
9th–10th century
marble

68 (right)
Male attendant
western India (Rajasthan?)
9th–10th century
limestone

10 (detail left)
Mithuna couple
central India (Madhya Pradesh)
10th–11th century
sandstone

The Hindu Holy Trinity is composed of the gods Brahma, Vishnu and Shiva. Every Hindu knows why Shiva wears a live cobra as a necklace (he tamed all nature's forces), or why Vishnu, embodying heroism, *vira*, has four arms (they suggest his superhuman prowess) and Brahma four heads (so that he can see in all four directions at once). The highly incongruous elephant-headed, pot-bellied god, Ganesha, radiating *adbhuta rasa* (strangeness), is loved like a relative. Hindus lavish equal adoration on the radiantly beautiful goddess, Lakshmi (wife of Vishnu) and the jet-black, hideous goddess Kali (Shiva's consort) who is seen trampling over her prostrate husband. In India, God is not seen merely as a male force. Indian gods and goddesses are on equal footing when it comes to power-sharing; indeed, as in the case of Kali, sometimes the goddess is more powerful.

All the gods are venerated because each one depicts a certain special aspect, or aspects, of the Universal. And since the Universal has myriad aspects, it is perhaps understandable that India has a galaxy of gods. This multiplicity of deities is the manifestation of the one ultimate reality, from which all flows and to which all must go. In Hinduism, to commune with any one of these is to be in touch with the divine.

Signs of the Divine

Most of the imagery in Indian art is symbolic. If a god or goddess sits or stands in a certain position, whether alone or in conjunction with other gods or humans, the pose instantly conveys part of the divine lore or a special spiritual message. For example, the four-armed Vishnu in a standing position is often seen carrying four attributes associated with his regal nature. The mace he holds in one of his hands announces his divine authority; the lotus in another signifies his links with the primordial waters from which all life sprang. The call of his conch shell can be heard resoundingly all over the world. The *chakra* (his divine discus) is a lethal weapon which can swiftly vanquish his foes.

Shiva as Maheshvara (Great God), sits in the lotus position. He is Prakasha, Light, the Primal Radiance. Uma, one of the names of his wife Parvati, sits on his left thigh. She holds up a

mirror in her left hand, not to exult in her own matchless beauty, but to proclaim to the world her true nature which is a reflection of Shiva's light and, by extension, that of creation. It is this very special light radiating from Maheshvara which makes Uma so unetherially beautiful – a perfect picture of a happily married couple resonating with *shringara rasa*, like a perfectly composed *raga* (melodic framework), a picture rich in symbols.

Kali, the most mysterious of all deities, is feared and revered as no other. Multitudes throng to her famous early nineteenth-century temple in Calcutta just for a brief *darshan* (a mere glimpse) of her diminutive black statue. Clad in deep red silks and heaped with her favourite blood-red lilies, Kali's red tongue lolls in lust for the blood of demons. Kali is the original mother goddess. She is *shakti*, power or force. All nouns in India have a gender and *shakti* is feminine: Kali remains feminine, despite her frightening countenance. She can appear also as Uma or Parvati, beauteous and tender, or again as Durga, the Unapproachable Warrior Queen. She is the female principle of creation – Mother, Time, the Destroyer, and, therefore, also the Creator. When she is seen standing on her prostrate spouse Shiva, she is illustrating the fundamental Indian belief that the female aspect of creation, that which gives birth to life, is superior to the male as represented by Shiva.

The Buddha sits in the lotus position, eyes half-closed, trance-like, indicating deep meditation and a state of higher consciousness. His hands are either held together on his lap, or they may be raised chest-high in other *mudras*. Sitting or standing, when the palm of his right hand is held open in *abhaya mudra* towards his devotees, like a hand mirror, he is offering them a benediction and reassurance, saying to them, 'Do not fear, I am with you'. His message is instantly understood in Sarnath in Bihar, east India (where he preached his first sermon after attaining Enlightenment in the sixth century BC), or by a devotee in Japan thousands of miles away in 2000 AD. When his hands and fingers are held in a circular *dharma chakra mudra*, a gesture indicating the wheel (*chakra*) of the law of duty (*dharma*), he is teaching the essentials of moral law as expounded by him.

25 (right)
Meditating Buddha
eastern India (West Bengal)
Pala period, 10th century
basalt

So many images tell well-known stories. For example, after a long duel with the giant serpent Kaliya, the victorious adolescent Krishna dances on the hood of the venomous snake in a superb bronze from south India. Having made himself master of the sacred river Jumna where it passed through the forest near Mathura, the dangerous reptile had begun terrorizing the local population of *gopas*, Krishna's rustic kinsmen. They had no one to turn to but the young god in their midst. Krishna responded with alacrity. The dreaded snake was subdued in a pitched battle and, Krishna's victory dance over, it was banished to the distant sea, never to return.

Perhaps the most memorable image in the whole of Indian sculpture is that of Shiva as Nataraja, 'Lord of the Dance'. It is the blissful dance of the cosmos of which Shiva is lord and master. He creates, he destroys, he creates – in a never-ending cycle of time. Indian tradition views time not as linear but as cyclical – without beginning or end. Trampling on a dwarf who represents ignorance, Shiva dances to the beat of the drum (Time itself), which he holds in his upper right hand, whilst the flame of destruction is in his corresponding left hand. His lower right hand is held up in the 'do not fear' *abhaya mudra*, while his fourth hand hints at protection for the devotee. The circle of flames surrounding the Cosmic Dancer symbolizes the universe in its cyclical continuation.

The image of Shiva Nataraja is perhaps the most dramatic single image in all art. Imperious and arresting in its majestic display of a compelling visual vocabulary, it radiates immense awe-inspiring dynamism. The palpable vitality of its movement and the totality of its impact grips us as few single images do. With his matted locks flying about furiously and his arms and legs in fast rhythmic motion, Shiva is not dancing to entertain, but to involve the world in his dance and to awaken it to the wonder of creation.

Work as Worship

The creation of a sculpted image was invested with a spiritual dimension – a prayer to the gods, meaningful only if the intellectual and psychological conditions were right. As with *yoga*, the sculptor's mind had to be rid of all worldly preoccupations. In the making of a piece of

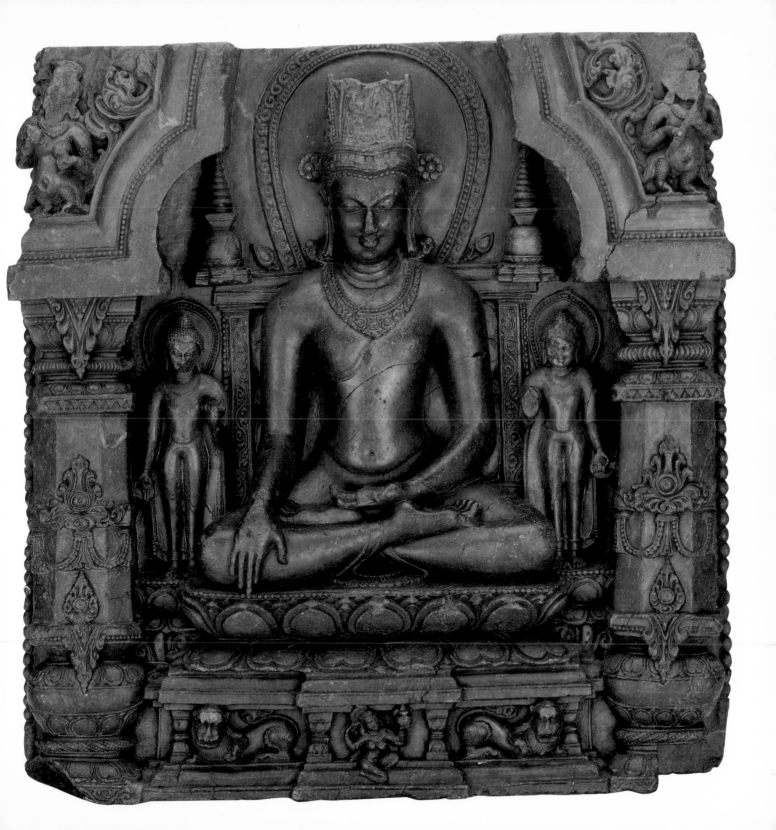

16 (below)
Birth of the Buddha
northern Pakistan (Gandhara)
Kushana period
2nd–3rd century
schist frieze

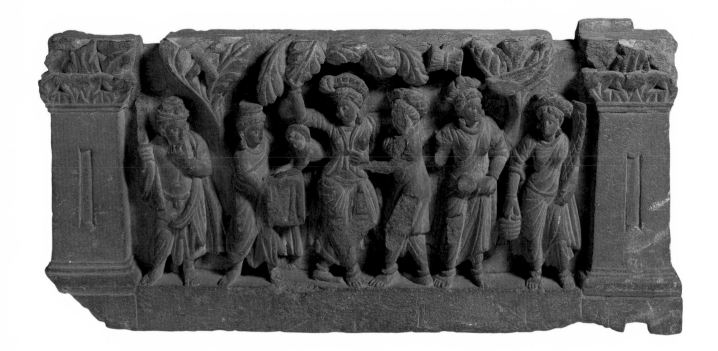

26 (opposite, left)
Maitreya
northern India (Kashmir)
11th century
bronze

28 (opposite, right)
Standing Buddha
northern India (Kashmir)
11th century
bronze

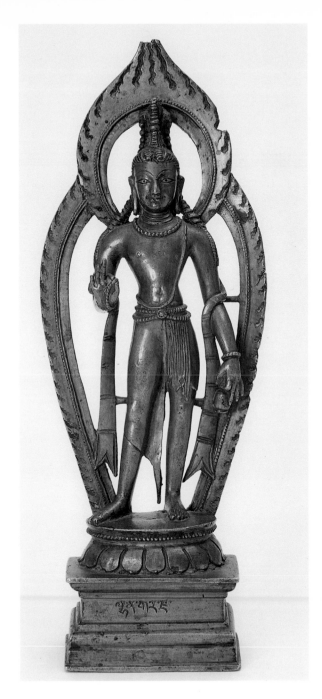 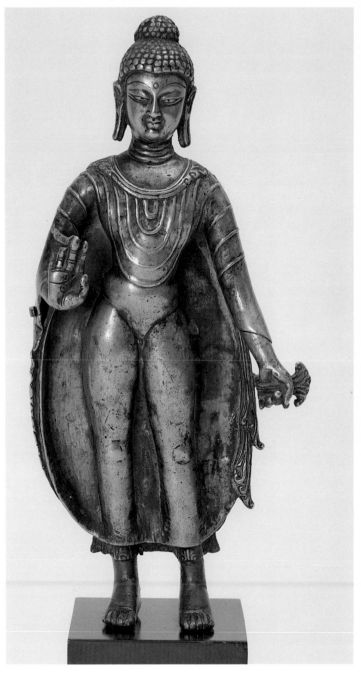

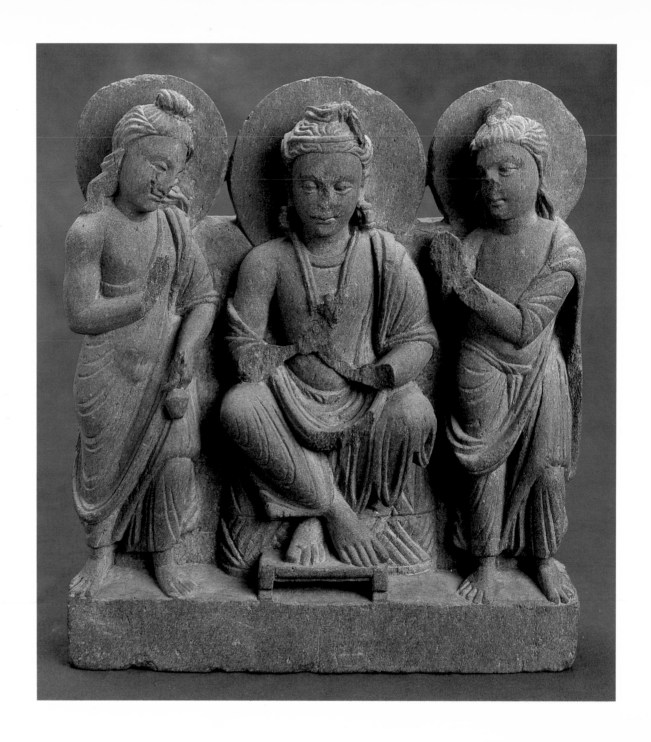

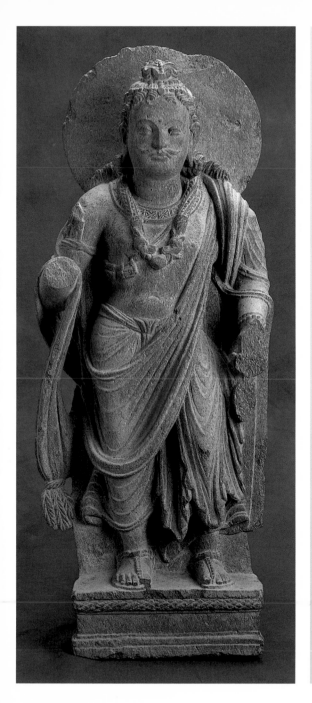

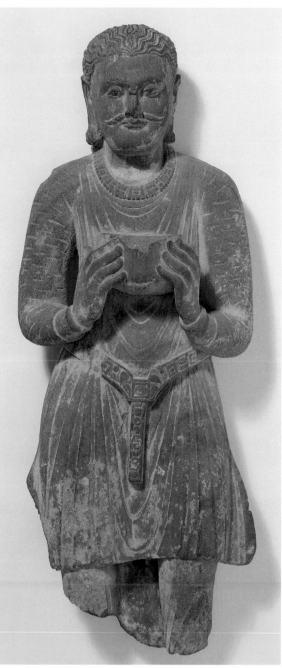

19 (opposite)
Seated Buddha and worshippers
northern Pakistan (Gandhara)
Kushana period
2nd–3rd century
schist

21 (far left)
Standing Buddha
northern Pakistan (Gandhara)
Kushana period
2nd–3rd century
schist

17 (near left)
Donor with casket
northern Pakistan (Gandhara)
Kushana period
2nd–3rd century
sandstone

22
Seated Buddha
northern Pakistan (Gandhara)
Kushana period
3rd–4th century
stucco

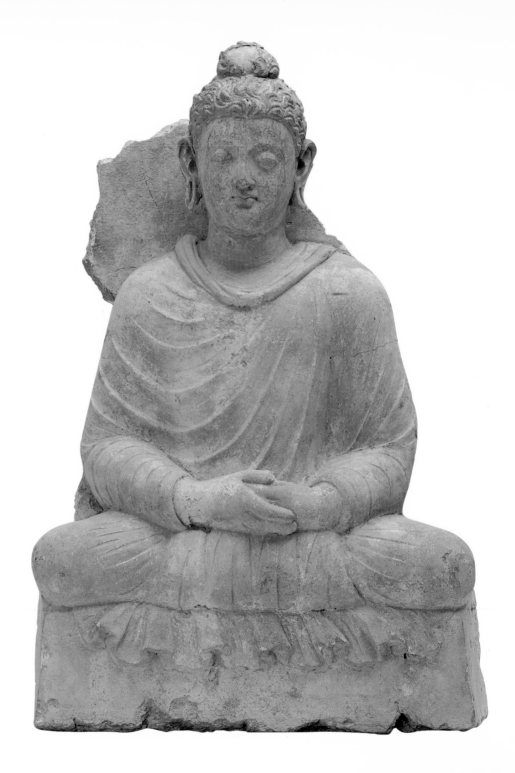

sculpture, say, a bronze in south India, its creator – not an artist in the Western sense, but a craftsman (one who had learnt his skills from his father and grandfather) – would have to purify his body by a daily ritual bath. He would compose himself to ensure not a trace of vanity or ego remained. This would not be a work of self-expression, but rather, through his providence-given talent, and sound, hereditary training, the sculptor would aim for a final product which would emanate spiritual benefits for all. When a devotee obtained a *darshan*, he would experience something of what the sculpted deity was intended to radiate – solace, serenity, reassurance. And enjoy its physical beauty too.

Once the bronze had been cast (using the lost-wax technique), sanded down, cleaned up and given finishing touches by chiselling and chasing, the image of the god would be carried in a procession to the temple, an event of great importance to the community. There, it would be installed at an elaborate ceremony attended by the entire village. From then on, it would be the temple itself which would have exclusive ownership rights to the image for all time, rather than its hereditary Brahmin priests, or the rich merchant donors who had financed the whole operation. On auspicious days of the calendar associated with the deity, the image would be anointed with *ghee* (clarified butter) and have saffron paste applied to its forehead. Then, gar-landed with freshly-cut flowers and wrapped in expensive silks, it would be paraded through the streets accompanied by chanting. With mounting fervour, people would line the streets for a sight of it in procession, creating an ambience of great excitement around the temple.

Temples in India, from the humblest to the grandest, would be built around a tiny, dark cell called a *garbhagriha* (womb-house), which contained the image of the deity to whom the temple was dedicated. In its simplest form, an Indian temple can be a single unadorned cell measuring only a few square feet. The grandest temples are lofty, conical edifices emulating the Himalayan snow peaks where the gods are said to dwell. Teeming with intricately carved images and designs, inside and out, they are the product of generations of jewellers in stone. Their aim is to involve the worshipper in celebrating the abundance of life as expressed by the bountiful carved representations of the earthly and the divine.

Sometimes colossal structures were cut out of rock, such as the breath-taking eighth century AD Kailasanatha Temple at Ellora in Maharashtra, a gigantic sculpture of architectural dimensions – the most monumental in existence – surely, a wonder of the world.

Sensuality and Spirituality

One aspect of Indian sculpture that Westerners find somewhat baffling is perhaps its un-abashed celebration of sensuality. Christianity's ultimate image is Christ on the cross. There is no such defining image in Hinduism, although Buddhism highlights detachment, and Jainism exalts the ascetic. Islam of course does not permit 'human' portrayal whether of the divine or profane. Depiction of sensuous pleasure has never been suppressed in Hinduism, because the human body is not seen as separate from the spirit. Even with Jainism, whose followers adhere to the world's strictest regime of vegetarianism, bordering on extremism, we see its godly Tirthankaras (divine preceptors) as well-proportioned, robust beings despite their austere diet. Although stern, they have a sense of well-being and exude a spiritual calm.

Even the Buddha displays a certain air of sensuality. He is usually seen with a slightly round belly, from the earliest of his representations (first to second century AD) from Mathura, 120 miles south of New Delhi. The flamboyant Bodhisattvas – the Buddhas to come, or those Buddhist sages who postponed attainment of their own *nirvana* in order to help others achieve theirs – from Gandhara (first to fifth century AD), a region spread over present-day northwest Pakistan and Afghanistan, are magnificently attired and sometimes moustached. They seem more like princes than Buddhist monks who earned their living by begging. Sculpted under Hellenistic influences (Gandhara was in close contact with Greece both culturally and aesthetically), these Bodhisattvas represent the essentially princely Buddha whose opulence was only abjured by the 'historical' Buddha, Siddhartha.

Hindu sculpture often radiates an extraordinary degree of sensuality, and India is dotted with temples amply demonstrating the fact that sensuality has always been at the heart of Indian creativity, itself a result of profound religious preoccupations. The reasons for this tantalizing

contradiction are as compelling as they are simple. Indians consider creation to be the consequence of male and female principles of nature coming together. They believe that the union of man and woman is not only obviously natural, but also something to be celebrated. It prefigures a transcendental, supreme bliss – the union of the human soul with the Great Soul, *jivatma* with *Paramatma*. Hindu art has traditionally celebrated the expression of sensuality as being fundamental to finding wholesomeness in life.

Vatsyayana's *Kamasutra* (fourth century AD), the world's first and most celebrated book on the art of love-making, is not a mere sex manual. Rather, it is a poetic treatise in which, according to Hindu principles, the joys of the erotic are extolled as essential to a balanced life. The twelfth century Bengali poet, Jayadeva, wrote some of the most moving love songs in world literature, which were devoted entirely to the love life of Krishna, the Divine Lover. And the tenth to eleventh century temples of Khajuraho in Madhya Pradesh and Konarak in Orissa, are festooned with explicit erotic imagery which, particularly at Khajuraho, is astoundingly beautiful. It charms, it seduces, it makes one wonder at the sheer audacity of its creators and their powers of conception and execution – bold but sensitive, fantastic yet poetic. It would be a grave error to regard these sculptures as anything but great works of art. They represent the beauty and the abundance of life in which the act of procreation is afforded a transcendental role. As Ajit Mukerjee has so aptly stated, 'These united male and female figures are drawn together in creative force towards the wakening of the inner spirit ... Filled with ecstatic conviction, they are no longer torn between the contradictions of life and social existence' (Mukerjee and Khanna, 1989).

Elsewhere in India, *mithuna* (couples engaged in amorous embraces) adorn the walls of temples and other religious buildings. They represent, often in high relief at the entrance of a temple, a warm welcome. So lovingly engrossed in each other and so effective through their fullness of form and rhythm, the presence of *mithuna* at a holy shrine bridges the gap between the human and the divine. It makes God less severe, bringing him closer to man.

Roots of Indian Art

The art of a country is the expression of its people's creative genius, a process which takes centuries to mature and acquire a distinctive identity. Historically, this process in India's case seems to have commenced in the fourth to the third centuries BC, when India became a political unity for the first time with the establishment of the Maurya empire (324-185 BC). But this journey had in fact begun already, some three thousand years previously, in the Indus Valley, northwest India – the Harappan civilization. However, this journey was interrupted when the highly sophisticated Harappans were overrun by Aryans from south-central Asia.

37 (above and detail right)
Varaha rescuing the goddess Bhudevi
western India (Haryana)
Chahamana period, 12th century
shale

First discovered by chance by British railway engineers in 1920, the ruins of the lost Harappan civilization's greatest city, Mohenjo Daro in Sindh, have since revealed thousands of objects and artefacts of everyday use, including the first works of sculpture created on Indian soil – some small-scale figures and a large number of exquisitely-carved seals. The seals contain a hitherto undeciphered script, but the astonishingly high degree of skill with which they were carved speaks volumes. Through them we learn something about the religious beliefs and aesthetic values of Indians in 3000 BC. Their objects of worship were the mother goddess, a Shiva-like deity and the phallus; the practice of *yoga* was also known to them. Such remains confirm that a well-developed artistic tradition flourished in northwest India at a time when the Great Pyramids in Egypt and Stonehenge in England were still in use. A small male torso in red sandstone further suggests that the uniquely Indian trend of investing godly figures with more than two arms was already in vogue c. 3000-2000 BC. The figure's two backward-moving arms are broken, but the two sockets on the front of the shoulders tell us something revealing – they were meant for dowelling to provide an extra pair of arms.

However, this tradition was arrested and relegated to oblivion when, c. 2000 BC, the Harappan civilization was destroyed by the militarily superior Aryans. References in the *Rig Veda* (the hymnology of the Aryans), speak of phallus-worshippers, and the subjugation of the Vedic god Indra, of the dark-skinned, indigenous people known as *dasus* (slaves), has been interpreted by scholars as referring to the subjugation of the Harappans by the Aryans.

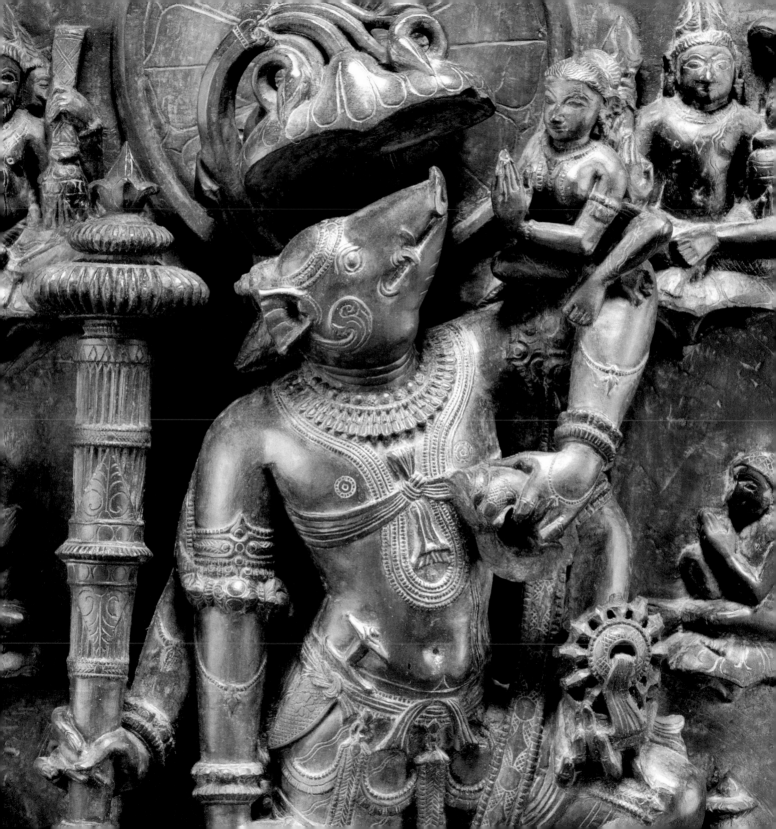

31 (right)
Torso of Vishnu
central India (Madhya Pradesh)
5th–6th century
sandstone

34 (opposite)
Vishnu's heavenly host
central India (Madhya Pradesh)
9th century
sandstone

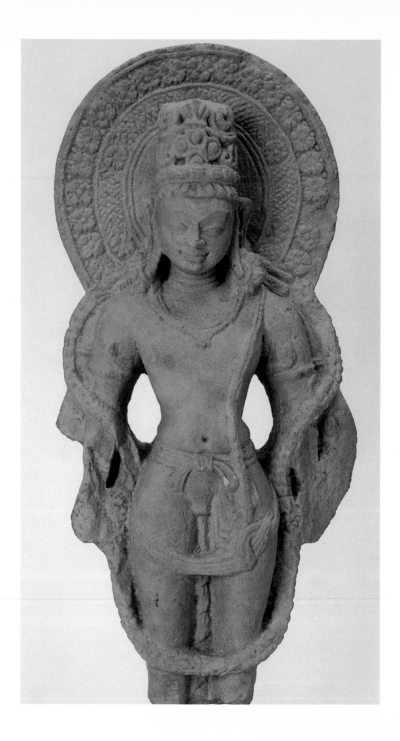

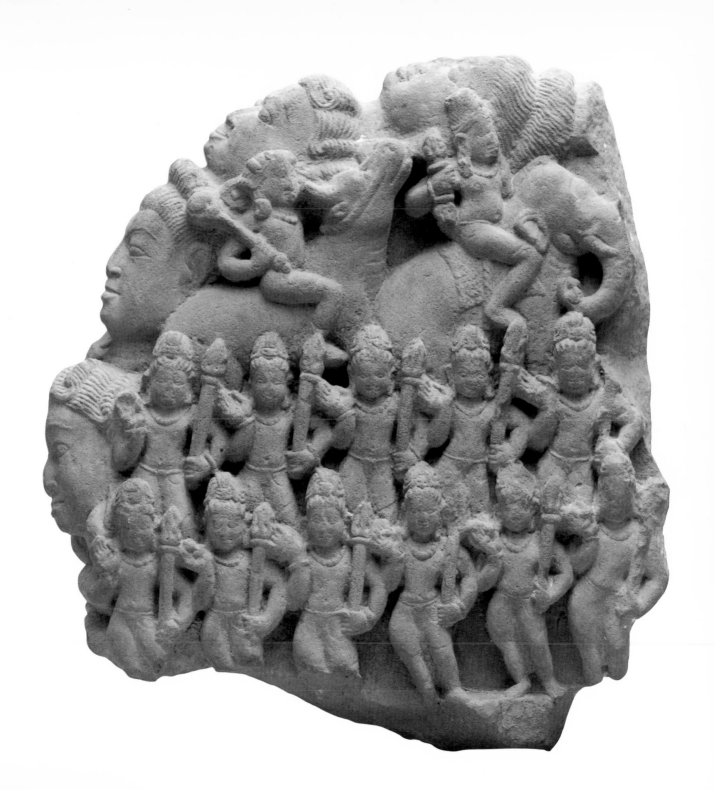

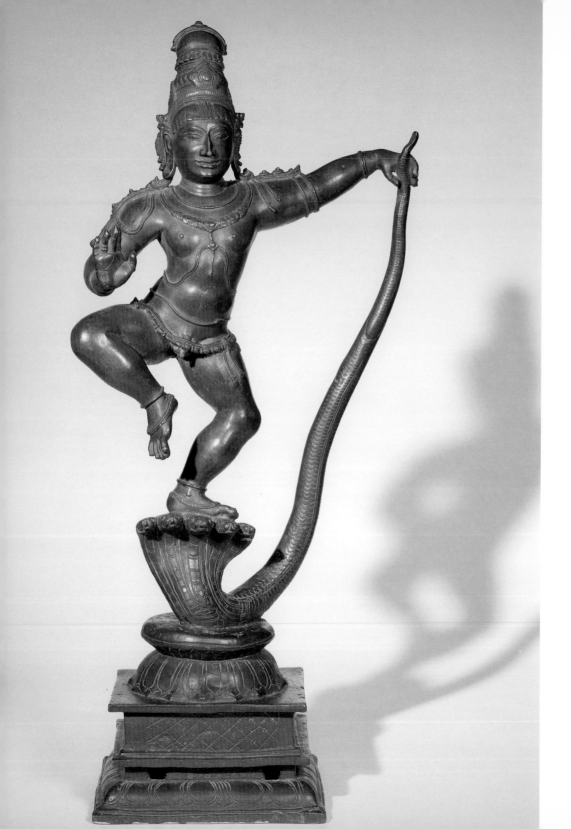

40 (left)
**Krishna dancing on
the serpent Kaliya**
*southern India (Tamil Nadu)
Vijayanagara period
16th–17th century
bronze*

32 (opposite, left)
Standing Vishnu
*eastern India (Bangladesh)
Pala period, 9th century
bronze*

35 (opposite, right)
Vishnu
*eastern India
Pala period, 10th century
bronze*

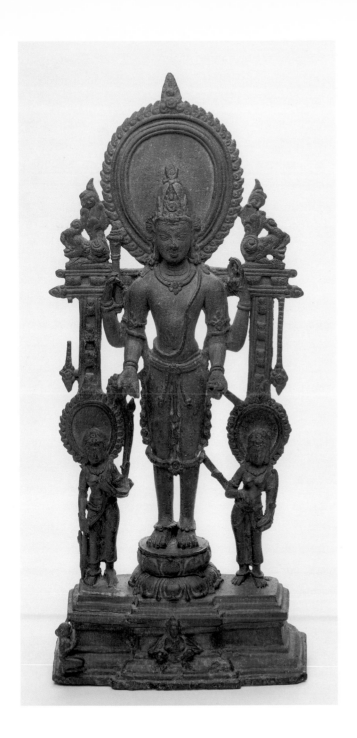

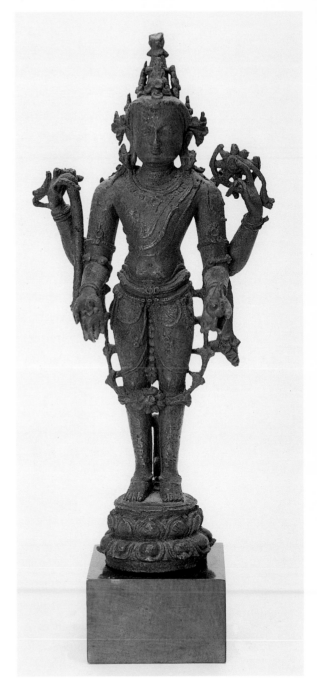

The destruction of one great civilization marked the beginning of another. If indeed the Aryans 'conquered' the original inhabitants, in the course of the next few centuries they themselves became 'Indian', proudly naming their new home Aryavarta – Land of the Aryans. They gave India their language, Sanskrit, the mother-tongue of all Indo-European languages, which they saw as 'the medium through which passes the light of knowledge' (Roberto Calasso, 1998). They constructed a new social order – the hereditary caste system – and imposed on India their world-view, their gods (they worshipped the elements) and their rituals. Roaming the lush plains of northern India, they composed the four great *Vedas* (books of knowledge) – poetic compilations of sublime beauty and metaphysics.

The *Rig Veda*, India's oldest sacred text of profoundly moving hymns, was composed from about 1500 BC onwards. It contained what its anonymous authors maintained was divinely revealed knowledge, *veda*. Three more *Vedas* followed between 1500 and 1000 BC. They had more hymns, and they dealt with science and sacrifice and how it had to be performed. Never written down, the *Vedas* were passed on orally from one generation to the next. The *Vedas* forged India's future cultural identity, becoming the basis for all its indigenous religions and much of its vast literature – inexhaustible storehouses of visual imagery. One day this imagery would inspire great works of art.

The Vedic period witnessed a relentless quest to understand man's place in the order of things. It saw the emergence of sacrifice as being fundamental to this quest. Sacrifices had to be performed perfectly, at particularly auspicious times, when the heavenly bodies were in a specific relation to each other. Sacrificial altars had to be of precise shapes and measurements, relating to the positions of the planets (the basis for future temple-building in India). Accompanying incantations had to be exact. For the latter, Sanskrit grammar and phonetics were perfected as had never been done in any other language. For the former, a whole new mathematical system was devised. This necessitated the invention of the decimal and numeration, of geometry and algebra. The early Indians also discovered *shunya* (zero) – one of the greatest contributions to human knowledge. Thus they were able to indulge in serious astronomical speculations involving vast distances, to construct an astronomical calendar, work out the earth's rotation around its axis and to calculate accurately its age.

For a thousand years, the Vedic Indians performed their sacrifices, chanted and speculated, but they left no art for us, only words. However, the synthesis of their values and beliefs with those of the earlier people (the Harappans) they had subdued, led to the creation of a wonderful and a vigorous new way of life in south Asia: Hinduism, which, in time, spawned both Buddhism and Jainism.

Of Gods and Men

In practice, Indians construed God as a composite of three aspects – creation, preservation and destruction – represented by Brahma, Vishnu and Shiva. Of the three, Vishnu and Shiva have always struck a chord in the Indian psyche, which explains why these two gods in particular were sculpted with such boundless vigour and devotion throughout the ages. Vishnu is colourful and fascinating – a god for all seasons and source of a whole library of stories for everyone's delight. He has ten incarnations, nine of which have taken place – the tenth is yet awaited. Whenever the world was exposed to a serious threat of extinction through the nefarious activities of demons and antigods, Vishnu would appear in a different form each time to save it. In this book, we see him in his third incarnation as Varaha, the powerful boar, rescuing Prithvi, Mother Earth, from perdition as she plunges to the depths of the ocean, lifting her up tenderly with his tusks (page 30).

Shiva is a mysterious and aloof mystic. He inhabits cremation grounds, living among ghouls and spirits. With matted locks and clad only in a tiger skin, he is a fearsome sight, wandering alone through the snows of the Himalayas, absorbed in deep meditation. A god of few needs, Shiva has all the forces of nature concentrated within him. The Destroyer, but also the Creator, he is Lord of the Dance of the universe. He is frequently worshipped in the form of a *Shiva linga*, a phallic symbol that is much more: an *axis mundi* or cosmic pillar that is the centre of the universe.

A Way of Life

As a way of life, Hinduism is the last great classical culture to survive into the twenty-first century. Unlike Christianity or Islam, there is no single authoritative book such as the Bible or the Koran; nor a messiah or a prophet at the pinnacle. Hinduism is based on precepts and principles; it views the phenomenon of life on earth as illusory, and believes in the transmigration of the soul and in the theory of *karma* – cause and effect of human action (act righteously in this life and you will be rewarded accordingly in the next). Hinduism's numerous gods are rooted in all Nature's aspects and forces. Constructing a colourful mythology according to these beliefs was a process begun by the Aryans early on, and it continues to this day. Thus the sun, which gave light and warmth, became the god Surya; the all-consuming fire became the god Agni, around whom daily rituals were performed and around whom all Hindu marriages still take place; Sarasvati, originally the name of a sacred river, became the goddess of learning and the arts ... and so on.

A New Light

After the *Vedas* came the *Upanishads* (1000-600 BC), Sanskrit metaphysical texts which questioned the *Vedas*, some even defying their philosophical authority. A thousand years of repetitive ritualism had ossified Hinduism, making it too rigid and its once-efficient caste-system divisive, even abusive. Although the *Upanishads* were as difficult for ordinary people to understand as the great *Vedas* had been, they nonetheless signalled a growing common concern. Spiritual India was ready for change.

Disillusioned with life, and especially with its inherent inequities, a 29-year-old Hindu prince, Gautama Siddharatha (563-483 BC), undertook an odyssey in search of the 'truth'. Unwittingly, he founded a new world religion – Buddhism – so named because after a long period of introspection, self-imposed privations and meditation, he had seen the 'light' and became the Buddha, the Enlightened One. This religion would change the shape of the entire East, from central to south-east Asia, with profound and far-reaching repercussions for its art, and especially for Indian sculpture. It may even be said that stone sculpture as a great art form

emerged in India as a direct result of Buddhism becoming its popular religion. But it had to wait for another few centuries before that could happen.

The Buddha's century saw the birth of another Indian religion, Jainism, which again represented a reaction against orthodox theocracy. It emphasized austere detachment and asceticism rather than a Middle Way and did not spread beyond India until recently. In the meantime, some vastly colourful literature appeared on the scene, enriching the visual language of the people. Two compositions, in particular, the *Ramayana* and the *Mahabharata* – long sagas of men and gods, of good and evil, of valour and war – offered Indian imagination a limitless source of stimulation.

However, it was with Buddhism that Indian sculpture commenced its great and glorious adventure. In particular, with two men: the prince, Gautama Siddharatha, who had attained 'Enlightenment', and the first major royal figure in Indian history to adopt his faith, Ashoka (r. 272-231 BC), some two centuries after the Buddha's death.

Buddhism's popularity lay in the simplicity of the Buddha's message, which was based strictly on non-violence. He preached charity to all creatures, equality among all beings and moderation in all things. He had rejected the Hindu caste-system, but retained its doctrine of the transmigration of the soul and kept the Hindu pantheon. Anyone could adopt Buddhism without renouncing his own religious beliefs, an open invitation to one and all. The light was lit. It would forever illuminate man's search for truth.

Buddhism – the Fount of Indian Sculpture

In 327 BC, Alexander the Great conquered the Gandhara region and parts of western Punjab. Even though he was on Indian soil for only eight months, Alexander left behind a lasting legacy and a Greek general, Saleucus, to run his distant Indian colony.

48 (right)
Shiva Nataraja
southern India (Tamil Nadu)
Vijayanagara period
16th century
bronze

Coinciding with Alexander's departure, there rose to prominence in north India another great young warrior – Chandragupta Maurya (r. 324-297 BC). Deposing the ruler of the substantial kingdom of Magadha, he pushed the Greeks back north to Gandhara. Thus was founded the Maurya empire – India's first – vastly extended by his grandson, Ashoka, covering most of the Indian subcontinent plus parts of Afghanistan.

One battle in Ashoka's glittering military career is of utmost importance to us, for it changed the course of Asian history and art. The battle of Kalinga in Orissa in 260 BC saw carnage on such a vast scale – over a 100,000 men killed – that it proved to be a turning point, not only in the young emperor's life, but also in world history. Moved by the folly of territorial ambition, Ashoka renounced war and violence and converted to Buddha's teachings. From then on, he made it his single ambition to spread his newly-adopted mentor's message. As a result, within a few centuries, Buddhism would become the main religion throughout Asia.

Ashoka was a charismatic and visionary ruler. No sculpted representations of him, the most celebrated of all India's kings and emperors, have survived. But what we have instead, as a direct consequence of his vision and enterprise, is the tradition of sculpture in India. We have a vast collection of imagery in stone, representing every episode of the Buddha's life and of his previous lives. For centuries after Ashoka – with Buddhism now the leading religion through-out India, Afghanistan and Sri Lanka – illustrating Buddhist legends became *de facto* acts of prayer for sculptors. Lovingly, they depicted how the Buddha was divinely conceived by Queen Maya, and how delivered; how he left his wife and newly-born child in the dead of night to search for the 'truth'; how he meditated and attained Enlightenment, to his last day on earth. They also illustrated the *jataka* tales, stories of the Buddha's previous lives.

Within his own domain, to commemorate the Buddha's life, Ashoka initiated an ambitious scheme of building thousands of *stupas*. A *stupa* is a semi-spherical structure with a flat top and an enclosure from which rises a tiered parasol. One of the most famous is at Sanchi, in central India, having a three-tiered parasol, symbolizing the three jewels of Buddhism – the Master himself, the *dharma* or moral law, and the brotherhood of monks. Buried inside the dome are

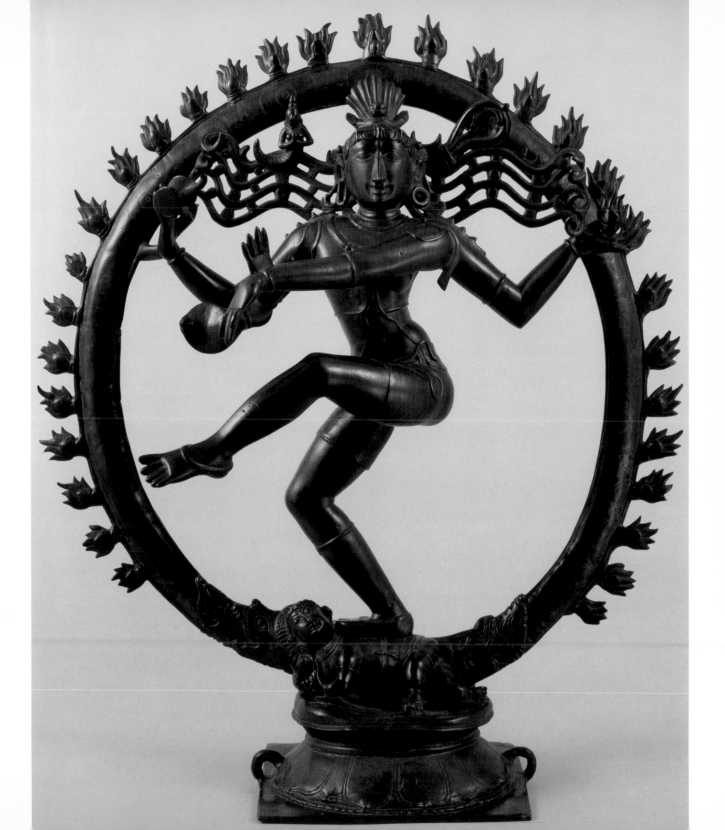

45 (right)
Uma Maheshvara
western India (Rajasthan)
11th century
marble

42 (opposite)
**Fragment of Shiva dancing
with an elephant**
central India (Madhya Pradesh)
10th century
beige sandstone

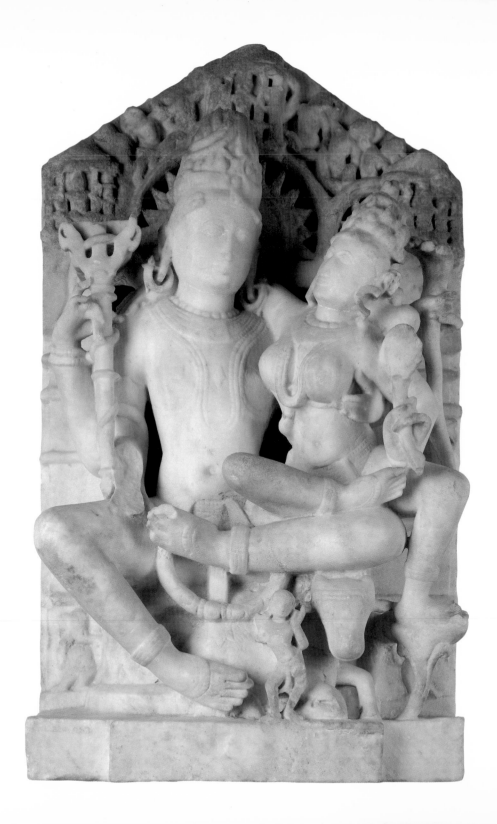

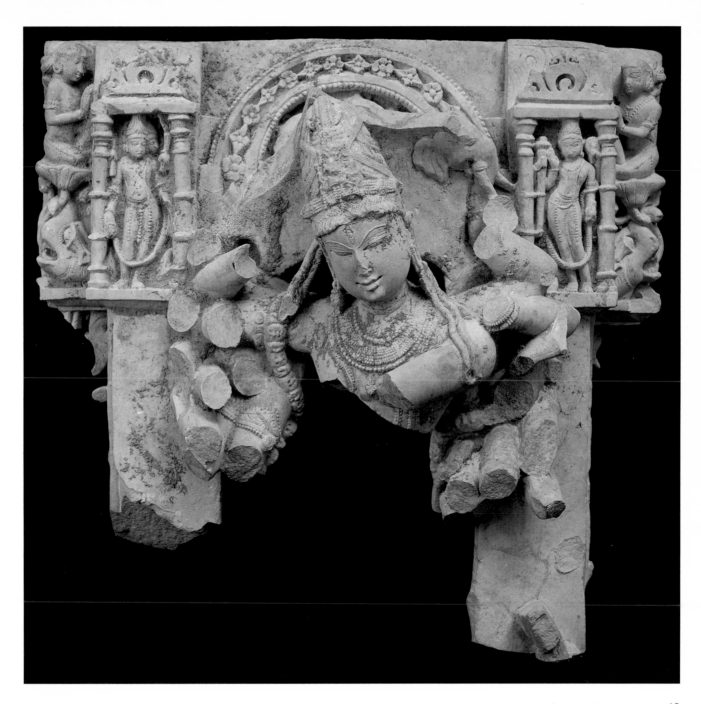

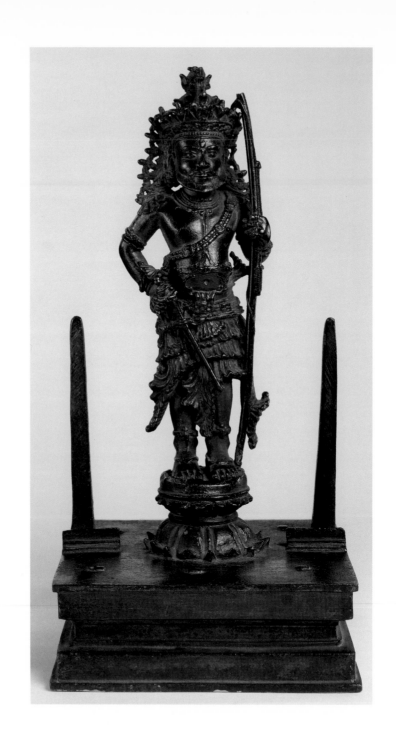

47
Shiva as the hunter
southern India (Kerala)
16th century
bronze

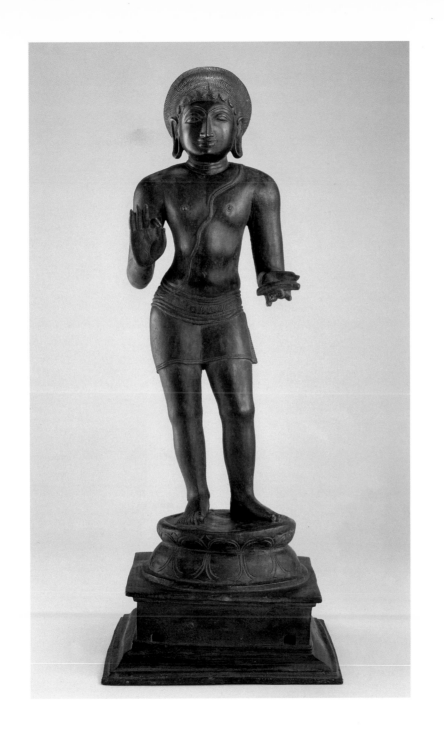

49
Manikkavachakar
southern India (Tamil Nadu)
Vijayanagara period
16th–17th century
bronze

45

33 (right)
Standing Vishnu
southern India (Tamil Nadu)
Chola period, 9th century
granite

50 (below)
Karaikkal Ammaiyar
southern India (Tamil Nadu)
18th–19th century
copper and lead

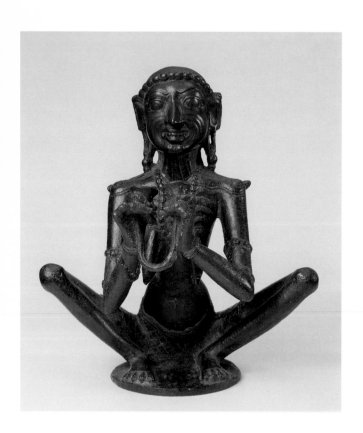

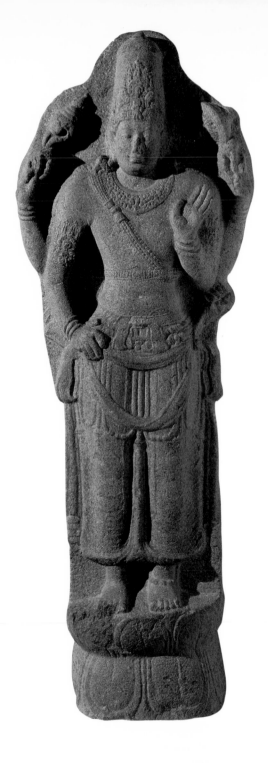

Buddhist relics. Ashoka thus established a great Buddhist architectural tradition. In time, the form of the *stupa* would spread to the whole of the Buddhist world.

To proclaim the message of Buddhism, Ashoka also had sculpted and erected throughout his vast realm, monolithic pillars of fine-grained sandstone with up to fourteen edicts inscribed on them that conveyed the *dharma*. The edicts were mostly in Brahmi script – the ancestor of all Indian scripts – and were in the local dialect. The capital often supported a realistically rendered animal, usually a bull, a lion (a symbol of the Buddha himself), or an elephant. These pillars could be about forty feet tall and weigh as much as sixty tons. The most celebrated of these is the pillar erected by Ashoka at Sarnath (where the Buddha first started preaching). Its two-metre capital depicts four lordly lions, imperiously looking in all four cardinal directions. Underneath are four other animals – a lion, a bull, an elephant and a horse – punctuated by the *dharma chakra*, the wheel of law. This capital, sculpted in the middle of the third century BC, forms the state emblem of the republic of secular modern India.

Monumentality is a distinctive feature of Maurya sculpture, along with a highly-polished surface. Another is the depiction of female beauty in the form of sensuous and full-breasted *yakshis* (nature spirits) in the typical *tribhanga* (triple-arched pose), role models for future feminine beauty. Sometimes, they are seen in the company of their male counterparts, the robust-looking *yakshas*.

The Shungas followed the Mauryas from 185 BC, ruling northern India for almost 100 years, but Buddhist art and architecture continued to flourish as well as that of the Jains. In fact it was during the Shunga period that Ashoka's great *stupa* at Sanchi was completely renovated, and embellished with four great gateways of stunning originality of design, called *toranas*. Densely populated with luxuriant carvings and figures in high relief, some almost free-standing, these thirty-five-foot high gates are complex, monumental sculptures in their own right.

Other great architectural enterprises were undertaken during the Shunga period, such as the rock-cut cave temples, finding their loftiest expression in the dramatic cave complexes of

Ajanta and Ellora, in the Deccan region – sublime achievements of architecture, sculpture and painting. On a more public level, terracotta mother goddesses made from elaborate moulds since Maurya times, now acquired a high flamboyance. Their head-dresses seem regal, if exaggerated, and a wealth of minutely-detailed jewellery covers their entire bodies. More *yakshis* and *yakshas* were sculpted in stone, such as those at the other famous *stupa* at Bharhut in Madhya Pradesh. These now began to appear as distinctly amorous, marking the beginning of the *mithuna* already discussed.

Gandhara – The Indo-Greeks

More foreign invaders arrived in the wake of the Shungas. The Kushanas from central Asia dominated northern India as far as Sanchi from the late first century to the fifth century AD. The Kushanas astutely converted to Buddhism, the religion of their subjects. Their greatest ruler, Kanishka (with capitals in Gandhara in the north at Kanishkapura near Peshawar and in the south at Mathura near New Delhi) was a devout Buddhist. Under him during the first half of the second century, two schools of sculpture simultaneously evolved in his two capitals and, for the first time, India had a glimpse of secular sculpture (some larger than life-size representations of Kanishka and his father have been found at an archaeological site in Mathura). And it was during this time that a fusion of Greek and Indian artistic traditions, known as Gandhara art, came into being.

Gandhara was on the old Silk Road. Here East met West. For centuries, its famous city Taxila had been a throbbing cultural centre renowned throughout the civilized world for its educational institutions – its university. It enjoyed direct trade links with Greece. The writer and historian, Lawrence Durrell tells us that there was not a single Greek philosopher in those times 'Who had not studied his philosophy in India' (Durrell, 1983).

Gandhara was also a melting pot for different races. Here, caravans from Greece, Rome and central Asia met those from China and India. The region greatly benefited from this mingling of commerce, races and ideas. And the whole of it was devoutly Buddhist, the rulers and the

ruled. Suddenly, their devotion erupted into stone – the local grey schist – resulting in the flowering of one of the most remarkable schools of sculpture in the ancient world. Its inspiration and subject matter was almost entirely Buddhist, though some Hindu deities were also sculpted, first by Greek sculptors and subsequently by their Indian disciples. Huge monasteries proliferated and *stupas* – great and small – dotted the land, with decorative friezes depicting scenes from the Buddha's life and previous lives. The monasteries were adorned with larger, more impressive images of the Buddha in his typical, trance-like stances. Also, there were the sometimes opulent Bodhisattvas, bejewelled and resplendent in their aristocratic apparel. The technique of rendering them was mostly Greek, but their body language entirely Indian – Greek appearances exuding Indian airs, classical Greek formality bathed in Indian sensuality. The Buddha's drapes may have been in Roman toga-like folds, but it is the simple Indian *dhoti* he is wearing, and he sits in the classical Indian lotus position with hands in Indian *mudras*. And the well-formed Bodhisattvas display distinctly central Asian facial features.

Ambitious and determined, Kanishka dutifully spread Buddhism to China and central Asia. In his own northern capital, he built, it is said, the ancient world's tallest building. Some 700 feet in height, the great Kanishkapura Stupa (since lost), must have presented a staggering spectacle to the people of Gandhara and their guests from the East and West, proclaiming the King's own greatness and that of his faith.

The Golden Age

In his southern capital at Mathura, Kanishka supervised the emergence of another vibrant centre of artistic production which would flower during India's classical age of the Gupta empire (320-550 AD). But the Mathura school of sculpture, using vibrant red sandstone, was quintessentially Indian in appearance and spirit, both Buddhist and Hindu. And it depicted, for the first time, the Hindu pantheon. Hindu gods and goddesses, such as Vishnu and Shiva, Lakshmi and Durga, came alive alongside Buddhist and Jain imagery, all made by the same sculptors. The large number of *yakshis* created here were more voluptuous, forerunners of later Indian sculptures. The *yakshas*, under Buddhist influence, became Bodhisattvas.

Up until this time, the Buddha had never been sculpted in human form. He was always represented by symbols – his footprints, the *bodhi* tree under which he had attained Enlightenment, the wheel of law, etc. It is claimed that it was here at Mathura, not Gandhara, that the Buddha made his first appearance in human form in sculpture. Whatever the truth, the sublime Mathura masterpiece depicting him sitting in the lotus position on a lion throne, has certainly entered the world's consciousness, for that is how he is seen the world over.

As a city, Mathura enjoys a special status. It boasts no great distinguishing features, such as grand palaces or temples, nor even impressive ruins on the scale of Mohenjo Daro. Yet it is a city of profound significance for Indian people in general (their favourite god Krishna was born here), and for the development of Indian sculpture in particular. Having enjoyed a glorious beginning during the Kushan times, Mathura became the epicentre of artistic creation during the Gupta period. Representations of the Buddha from here and Sarnath exude the essence of Buddhist philosophy – total serenity, a deeply felt inner calm and an all-pervading feeling of peace – as effectively as is possible for a stone image to achieve. The Gupta period saw Indian creative spirit reach a high level in every sphere: science and medicine, painting, poetry, dance and drama (Kalidasa, 'India's Shakespeare', lived during the fourth to the fifth centuries AD), architecture and especially sculpture.

Among the steps the Gupta kings undertook to channel Indian creativity, the one to have resounding consequences was the consolidation of sculpture ateliers at Mathura in the heart-land of the country. Already renowned, during the next two hundred years of uninterrupted peace and prosperity, they were to become hugely prolific, forging a distinctive Indian identity.

Artistic impulses would radiate from the Gupta period, permeating, in time, the collective creative psyche of Indian people. From the eighth century onward, these impulses burst forth into a thousand different manifestations, like the gods they were to serve. From Kashmir in the north to Kanya Kumari in the south, from the desert of Rajasthan to the delta of Bengal, an abundance of different styles encapsulating local idiom, legend and lore flourished. This nationwide undertaking, uncoordinated for most of the time yet consistently informing and

inspiring regional genius, would make India one of the world's richest repositories of art and establish, what the eminent art historian, Basil Gray, declared to be 'the longest-lived great tradition of sculpture that the world has seen since that of Pharaonic Egypt' (Gray, 1995).

Further reading

Roberto Calasso, 1998, *KA*, Jonathan Cape, London

Lawrence Durrell, 1983, 'From the Elephant's Back' in the *Times Education Supplement*, London, September (from a lecture at the Centre Georges Pompidou, Paris, April 1981)

Basil Gray, 1995, 'Douglas Barrett at the British Museum' in John Guy (ed.), *Indian Art and Connoisseurship*, Mappin Publishing Pvt Ltd, New Delhi

John Keay, 2000, *India, A History*, Harper Collins, London

Jonathan Mark Kenoyer, 1998, *Ancient Cities of the Indus Valley Civilization*, Oxford University Press, Karachi

Ajit Mukerjee and Madhu Khanna, 1989, *The Tantric Way*, Thames and Hudson, London

John M. Rosenfield, 1967, *The Dynastic Arts of the Kushans*, University of California Press, Berkeley

Henri Stierlin, 1998, *Hindu India*, Taschen, Cologne

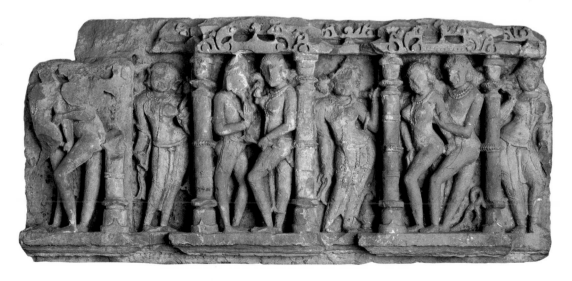

8
Mithuna couples
*western India
(Gujarat or Rajasthan)
9th–10th century
sandstone frieze*

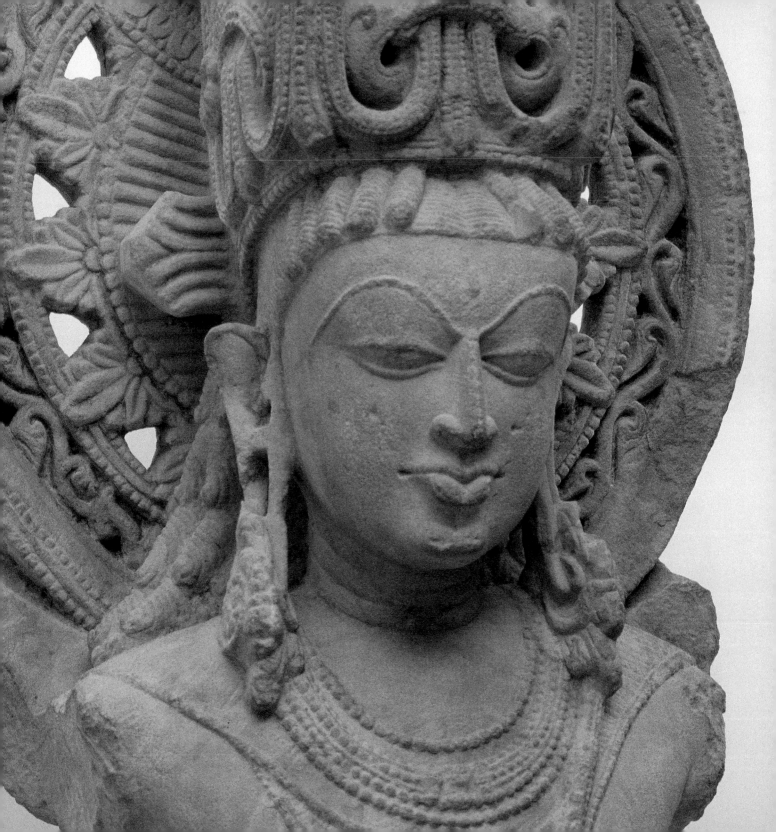

55 *(detail left and above)*
Torso of Surya
central India (Madhya Pradesh)
7th–8th century
sandstone

58 *(right)*
Seated Kubera (?)
central India (Madhya Pradesh)
11th century
sandstone

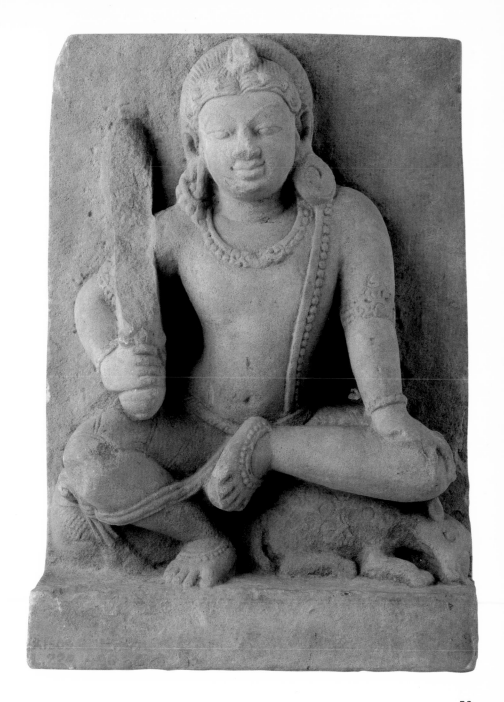

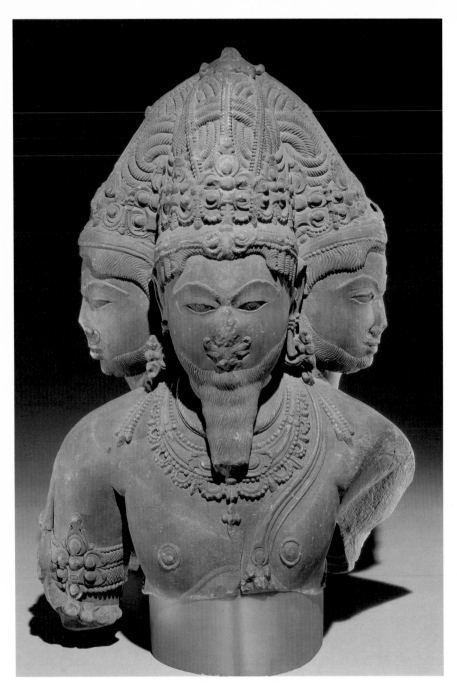

56 (left)
Head of Brahma
central India (Madhya Pradesh)
10th century
sandstone

57 (right)
Standing deity
central India (Madhya Pradesh)
Chandella period, 10th century
beige sandstone

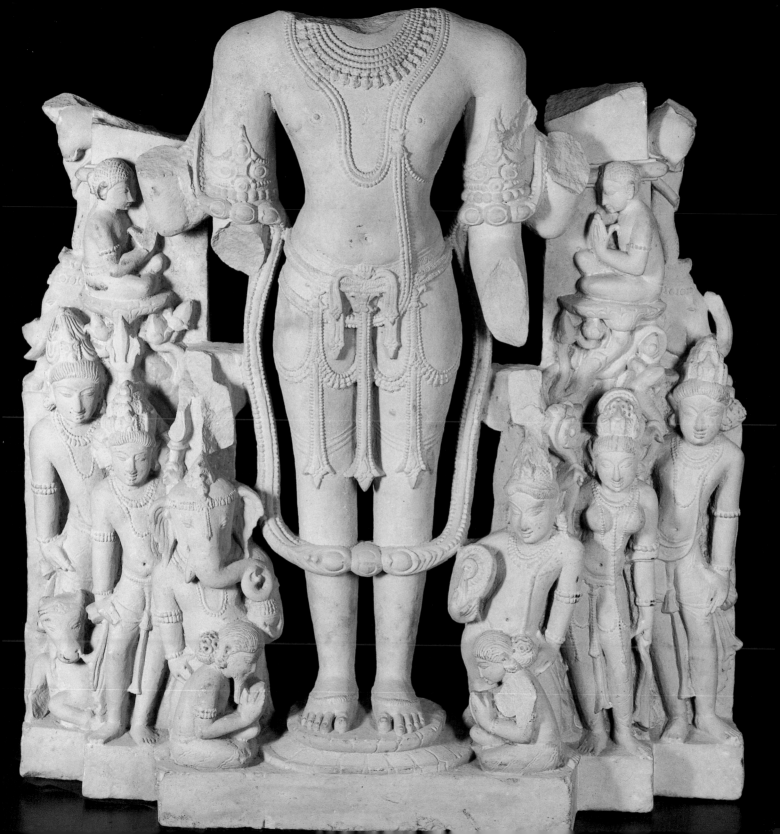

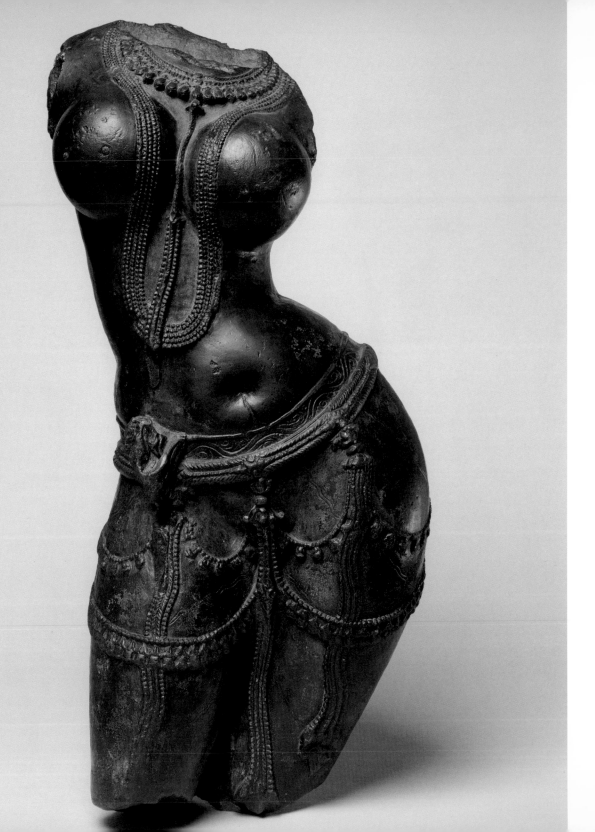

GEORGE MICHELL *The Figure in Indian Sculpture*

Indian sculpture is primarily an art of the figure. The human body is used to portray the gods and goddesses of Hinduism, as well as the saviours and saints of Buddhism and Jainism. In the arts associated with these religions, male and female human bodies are altered and elaborated so as to express super-human powers. While such physical transformations lie at the core of this sacred imagery, Indian sculptors never abandon their concern with the natural world: the figures that they created through the centuries, in terracotta, stone, metal, wood and ivory, are at the same time human and divine.

Many of the ideas governing the forms of Indian images and the rituals associated with their worship may be traced back to the shadowy world of the third and second millennia BC. However, continuous artistic traditions in India date from only the third and second centuries BC. The images assembled here testify to the miscellany of forms and styles that developed in the different regions of India, as well as in the neighbouring countries of Pakistan and Bangladesh.

Northern India and northern Pakistan

Two thousand years ago, much of the Indian subcontinent came under the sway of invaders from central Asia. Known as the Kushanas, these new masters were of outstanding importance for the development of art traditions since it was under their patronage that the first images of the Buddha were fashioned in stone and plaster. Most of these icons were intended for the shrines and monasteries established in the Gandhara region of northern Pakistan, and in and around the city of Mathura in Uttar Pradesh, the two main centres of Kushana power. Gandhara sculpture is distinguished for its obviously Hellenistic appearance. Such foreign

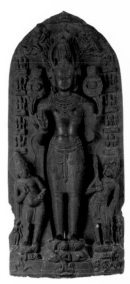

59 (above)
Surya
eastern India
Pala period, 11th century
shale

9 (left)
Female torso
western India (Rajasthan)
10th century
black chlorite

artistic influence is explained by the constant traffic of people and goods along the land routes linking the eastern Mediterranean area with the Indian subcontinent. Classical derived features include the naturalistic depiction of the human body, the animated poses of the figures, and the richly modelled draperies. The use of the halo and the preference for clearly defined hand gestures – meditating, teaching, protecting — are, however, indigenous characteristics. Nowhere is the mingling of Hellenistic and Indian attributes more evident than in the stucco icon of the Buddha seated in meditation (cat. 22). The figure has clearly modelled eyes and aquiline nose, elongated ear lobes, and a topknot protruding from the curly hair. Pleated robes fall lightly around the body, highlighting the Buddha's inner repose.

Similar characteristics are also present in schist icons of the Buddha such as those portraying the first sermon at Sarnath, the hands together in the gesture known as 'untying the knot of delusion'. In relief representations of this scene, the Buddha is flanked by worshippers (cats. 19 and 25), or meditates in the company of devotees (cat. 20). Another similarly-styled panel relates the miraculous birth of the Buddha, with his mother Maya clutching an overhanging branch of a tree (cat. 16). An attendant lightly touches Maya's stomach, while the miniature figure of the newborn baby emerges from Maya's hip to be received in a towel held by another attendant.

Monumental standing Buddha images are also known in Gandhara art, generally with one hand up in the gesture of protection (cat. 21). Such icons present the Buddha as a royal figure, with moustache and flowing hair, decked in jewellery and dressed in robes and sandals. Another facet of Gandhara sculptures is represented by the human donors dressed in the girdled tunics typical of Kushana attire. One such figure with a beard and curly hair strides forward bearing a casket (cat. 17).

Kushana art from Mathura is immediately distinguished by the mottled red sandstone found in this area, and the lack of obviously Classical influence. Buddha images from Mathura are impressive for their imposing stance and clarity of facial expression (cat. 18). Fully-rounded planes also characterize the gracefully-posed *yakshi* putting on a necklace (cat. 6). Related to the *yakshis* of the preceding Shunga period, this example expresses the fleshy modelling that

signals the Mathura Kushana style. As in earlier figures, the ample hips and jewelled belt draw attention to the maiden's sexual parts. She stands on a grimacing dwarf, while a face stares enigmatically out of a window above.

Central India

From the fifth century AD onwards, a succession of dynasties governed the central zone of India, a vast area encompassed by the modern states of Madhya Pradesh and Uttar Pradesh. They included the Guptas in the fourth and fifth centuries, the Pratiharas in the seventh and eighth centuries and the Chandellas in the tenth and eleventh centuries. These and other rulers of this region sponsored shrines dedicated to different Hindu gods and goddesses, and even on occasions to the Jain saviours. Temples built out of red or yellow sandstone, such as those at Khajuraho in Madhya Pradesh, demonstrate an intimate relationship between sculpture and architecture.

An early example of the central Indian sculptural style is the fifth to sixth-century sandstone image of Vishnu assigned to the post-Gupta period (cat. 31). The god stands in a commanding pose, decked in garlands and wearing a decorated crown framed by a halo embellished with floral ornament. In a similar seventh to eighth-century composition, the head of the solar deity Surya is surrounded by a halo partly cut out as a cosmic wheel (cat. 55). The curly hair of the god is mostly hidden by a crown ornamented with a monster mask. The face is elegantly composed with markedly arched eyebrows and aquiline nose. Comparable hair-styles and arched eyebrows are seen in the tenth-century bust of the triple-headed Brahma (cat. 56). The central head of the deity is distinguished by the tightly woven beard that hangs over the elaborately jewelled necklace.

The solid quality of central Indian figural art in the tenth and eleventh centuries is present in the panel showing a seated figure, possibly Kubera, holding a club (cat. 58). His impassive pose contrasts with a group of goddesses known as the Mothers, or *Matrikas*; they include boar-headed Varahi and skeletal Chamunda (cat. 43). Together with Ganesha, they stand with

their knees bent in the act of dancing. A similar movement animates the crowd of swaying celestials armed with tridents that constitute the celestial host of Vishnu as Vaikuntha (cat. 34). In this form the god appears with a central human head flanked by animal heads referring to Varaha and Narasimha, Vishnu's boar and lion incarnations respectively (cat. 36).

Sculpted deities in formal compositions are often surrounded by symmetrical arrangements of subsidiary consorts, attendants and guardians. The broken panel showing a richly-jewelled and elaborately-dressed male god, almost completely cut out in the round, has kneeling devotees at his feet and at either side (cat. 57). A diminutive Ganesha is seen to the left. More dynamic in conception is the carved fragment portraying Shiva dancing triumphantly, holding up the skin of the elephant demon that he has just slain (cat. 42). Though damaged and incomplete, the panel contrasts the serene face of the god, tilted gently to one side, with the cluster of sixteen arms flung out in all directions of which only the stumps remain.

Jain Tirthankaras are more impassive, as is evident in the eleventh-century saviour with an auspicious diamond-shaped mark on his chest, seated in meditation beneath a multi-tiered parasol (cat. 65). The pair of lions beneath the throne identifies the figure as Rishabhadeva. While the Tirthankaras are generally considered ascetic, they are sometimes associated with goddesses known as *yakshis*. Such a figure is Chunda sitting calmly on a lotus seat surrounded by devotees (cat. 62). The goddess holds a mirror in one hand; with the other she applies a beauty mark to her forehead.

A ubiquitous deity in Indian sculpture is Ganesha, recognized by his elephant head flanked by large flapping ears. In the eleventh-century panel, Ganesha picks up a sweet from a bowl held in one hand (cat. 44). The protruding pot belly with snake belt affirms his propitious role as remover of obstacles. Equally felicitous are the dancers and musicians that populate Hindu and Jain temples, such as the pair of beautiful maidens, or surasundaris, one dancing, the other playing a small drum (cat. 11). Warriors, too, sometimes assume dynamic poses, especially when depicted flying through the air. The figure shown on page 73 brandishes a sword that touches his curvaceous back (cat. 69).

Central Indian temples are also renowned for their frank depictions of sexual scenes, with couples known as *mithuna* shown in a variety of embraces, including copulation. While the precise meaning of these figures is still debated, it seems certain that they were imbued with a magical efficacy. The couple in a tenth-century panel expresses a tenderness that is far removed from pornography (cat. 10). The female reaches forward to fondle the phallus of her lover, while lifting up her face to receive a passionate kiss.

Western India

Art traditions in western India between the ninth and twelfth centuries flourished under the Pratiharas of Rajasthan, the Solankis of Gujarat and the Chahamanas of Haryana. Most of these kings erected Hindu temples, but some were also responsible for Jain monuments, such as the renowned group on Mount Abu in southern Rajasthan. White limestone and marble were the preferred materials in these zones, as in the eleventh-century panel portraying Shiva with his consort Parvati in a composition known as Uma Maheshvara (cat. 45). Here the god and goddess are seated in affectionate embrace, their arms wrapped around each other. Shiva holds a trident, his characteristic weapon, while Parvati clutches a lotus flower. The god wears matted hair and long earrings, while a perforated spoked halo is set behind his head. Nandi, his bull mount, is seen beneath.

This scene of domestic peace contrasts with a twelfth-century sculpture of Vishnu in his incarnation as Varaha, one foot lifted up in the act of stepping out of the cosmic ocean (cat. 37). The boar head of the god is raised so as to nuzzle the diminutive figure of Bhudevi, the goddess he has just rescued. Devotees and sages are witness to this miraculous deliverance. Similar accessory figures appear in other compositions, sometimes surviving as sculptural fragments (cats. 7 and 68). The male figure, possibly a guardian, has one arm raised up as if to carry an emblem of the deity that he serves, but this is now broken; the female holds a *vina*, a stringed instrument with acoustic gourds.

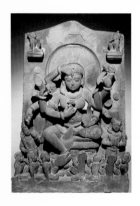

62 (above and detail right)
Chunda, a Jain yakshi
central India (Madhya Pradesh)
10th century
sandstone

Other western Indian sculpture includes the embracing *mithunas* on a ninth to tenth-century frieze (cat. 8). The couples are portrayed in a variety of frankly sexual postures. Together with surasundaris, with whom they are interspersed, the *mithunas* appear in rhythmic swaying postures. The same posture is apparent in the damaged tenth-century torso of a female figure executed in glistening black chlorite (cat. 9). The extravagance of the jewelled necklaces, belts and tassels complements the opulent sensuality of the full breasts, narrow waist and ample hips. It is likely that she is a surasundari, a companion perhaps to the eleventh-century female carved onto a marble block (cat. 12). Though this second female is less exaggerated in posture, her body has the same fleshy generosity.

That sculptural traditions continued into recent times in western India is evident from the nineteenth-century marble figure of Chandraprabhu (cat. 67). Seated cross-legged in the lotus posture, the palms of the hands resting in the lap, the Jain saviour stares straight ahead, his eyes wide open. The anti-naturalism of the composition is striking when compared with earlier western Indian art. Rather than embodying life-enhancing values, the figure seems to belong to the abstract realm of Jain metaphysics.

Kashmir

Sculptural traditions in the northernmost part of India are best preserved in the remoter sub-Himalayan valleys, such as that of Kashmir. Buddhist bronzes from this zone have elongated proportions and somewhat languid expressions. The eleventh-century image of Maitreya, the Bodhisattva yet to appear, stands on a lotus base, surrounded by a fiery frame culminating in a halo (cat. 26). That Maitreya is essentially a teacher and saviour is indicated by the ritual water pot and rosary held in both hands; even so, he wears a crown to convey his celestial nature. A similar crowned figure is recognised as Padmapani by the lotus stalk that he holds, the flower having been lost (cat. 27). The Buddha, too, appears in Kashmir art, dressed in a pleated cape, gesturing protectively with his right hand (cat. 28). Unlike the Bodhisattvas, the Buddha is bare headed, with the hair arranged in tight curls topped with a small knot.

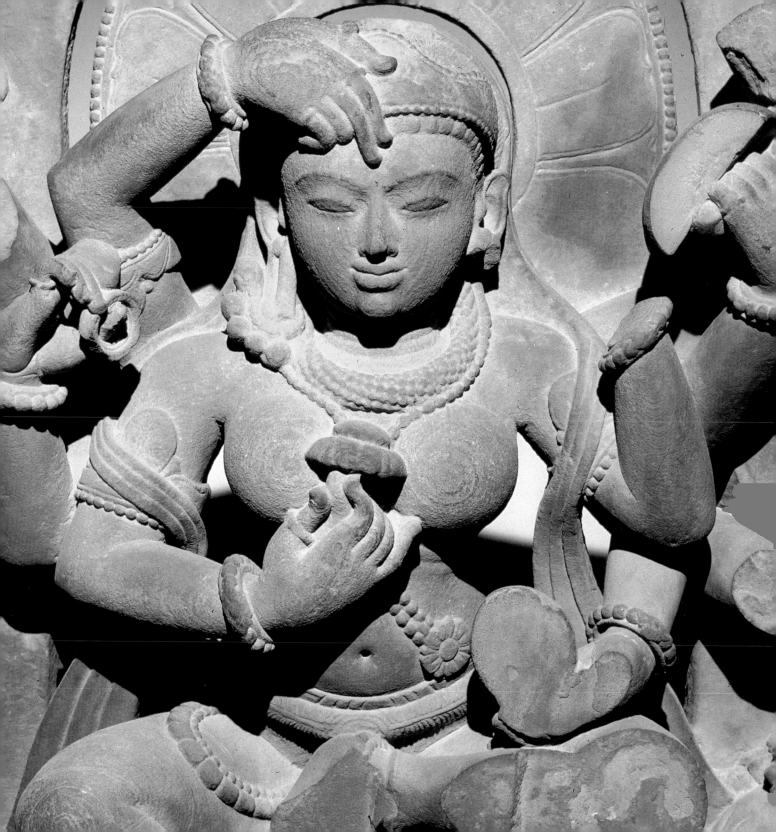

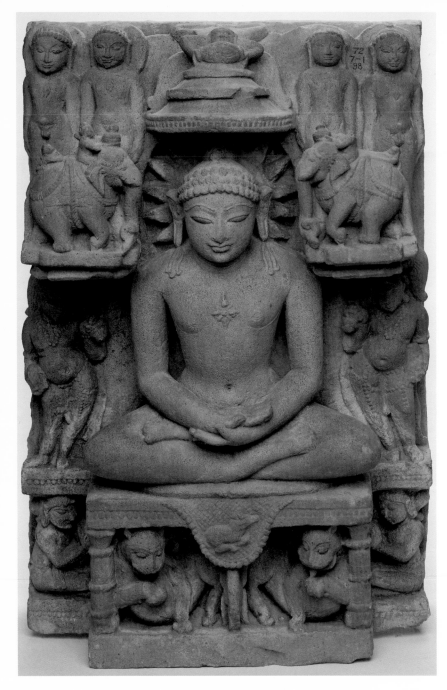

65 *(left)*
Meditating Rishabhadeva
central India (Madhya Pradesh)
11th century
sandstone

63 *(right)*
Standing Jain saviour
Deccan (Karnataka)
Ganga period, 10th century
shale

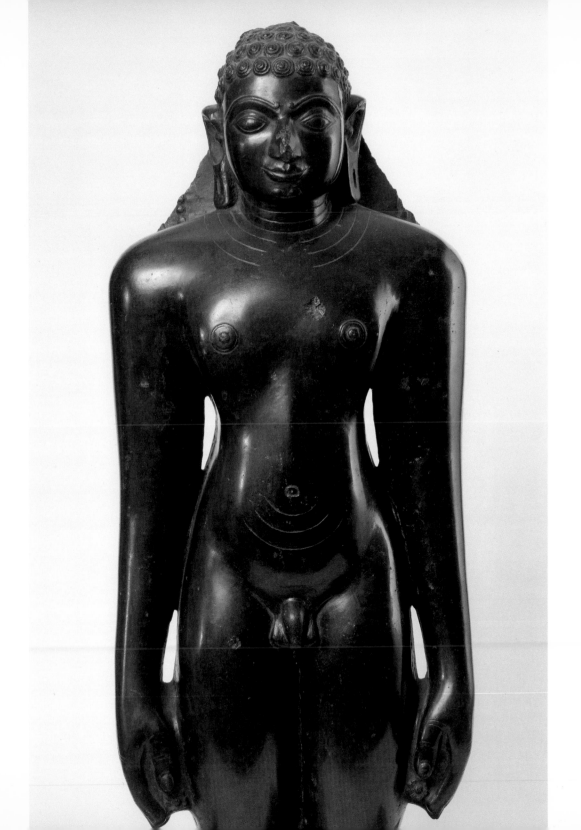

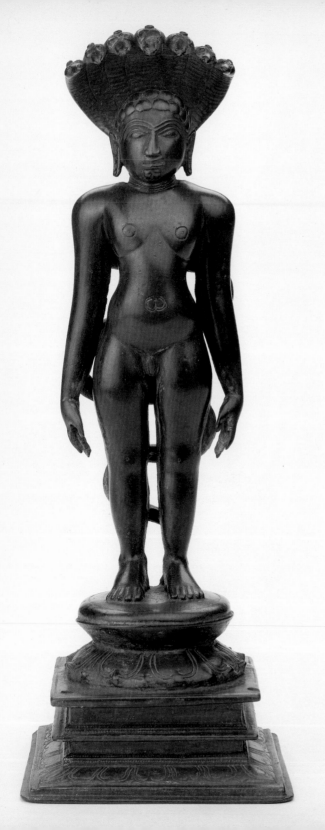

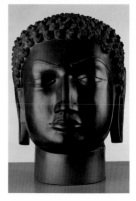

64 (above and detail right)
Head of a Jain saviour
Deccan (Karnataka)
Ganga period, 11th century
shale

66 (left)
Parshvanatha
Deccan (Karnataka)
14th century
bronze

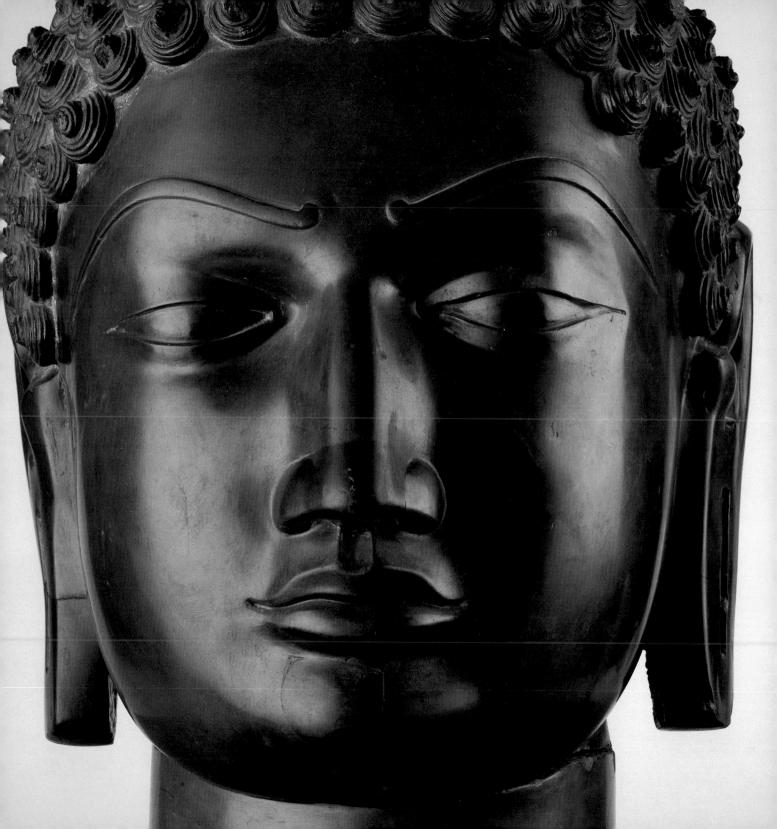

Eastern India and Bangladesh

The eastern part of the Indian subcontinent, comprising the modern states of Bihar and West Bengal in India and neighbouring Bangladesh, came under the sway of the Palas, the major rulers of this zone from the ninth to the twelfth centuries. The region incorporated ancient Buddhist centres such as Bodhgaya in Bihar, the site of Buddha's *nirvana* under the *bodhi* tree, as well as the great monastery at Nalanda also in Bihar. While the brick structures at these and other sites erected by the Palas are now ruined, numerous stone carvings and bronzes of the period survive.

Bronzes constitute an important category of Pala art. An intricately-worked ninth-century example from Bangladesh portrays Vishnu standing within an ornate frame supporting a flaming halo behind the god's crowned head (cat. 32). Diminutive figures of Lakshmi and Bhudevi appear beneath at either side. The god holds the characteristic disc and conch in his two left hands, and a mace in the rear right hand. Almost exactly the same scheme is adopted in the twelfth-century bronze, but here the frame is solid with a semicircular top (cat. 38). In another image from the tenth century, Vishnu stands alone, his body outlined with considerable delicacy to create a sinuous silhouette, enhanced by the cutout tufts and tassels (cat. 35).

Nor is Vishnu the only Hindu divinity to appear in Pala art. Surya is portrayed, somewhat unusually, with four arms, the rear two hands holding full lotus blossoms (cat. 59). The tunic and boots worn by the god indicate his foreign origins. Smoothly but robustly modelled in blackish shale, the eleventh-century figure is typical of Pala stone art. The same attributes are apparent in the twelfth-century panel portraying the snake goddess Manasa (cat. 60). Seated on a lotus throne beneath a protective cobra with multiple hoods, Manasa holds another snake in her left hand.

Buddhist stone sculptures in the Pala period are comparable to Hindu icons, as is evident in the tenth-century basalt composition of the Buddha seated in meditation within an ornate lobed frame (cat. 25). His smoothly-modelled body, dressed in elaborate jewellery and wearing a high

crown, is cut out in almost three dimensions. The right hand gently touches the ground, summoning the earth to witness his *nirvana*. That this composition draws its inspiration from earlier bronzes is suggested by the small icon dating from the sixth to seventh centuries showing the Buddha in the same earth-touching gesture seated beneath the *bodhi tree* (cat. 23). He is dressed in a simple costume, and is bare headed, in contrast with Bodhisattvas who wear elaborate jewellery and crowns, such as the twelfth-century inlaid bronze of Padmapani (cat. 29). This figure is seated with one knee raised, the body gracefully tilted at the hips and neck. Only the stalk of the lotus held in the left hand remains. Here, too, should be mentioned the diminutive moulded terracotta plaques made for pilgrims to the holy Buddhist sites of Bihar. A ninth-century example, possibly from Nalanda, shows the seated Buddha gently touching the earth with his right hand (cat. 24).

Orissa on the Bay of Bengal is another region of eastern India with a distinguished art tradition. Monuments erected there under the Ganga rulers in the twelfth and thirteenth centuries include the celebrated Hindu temples at Puri and Konarak. The panel shown on page 15, possibly from the latter monument, shows a sensuous maiden standing beneath a tree (cat. 13). Her smiling expression, large eyes and pointed ears are typical features of the Orissan style.

The Deccan

Peninsular India, comprising the modern states of Maharashtra, Karnataka and Andhra Pradesh, is also of importance for its sculptural heritage, especially that which flourished in the context of Jainism. Deccan figural art was much patronized by the Ganga rulers of Karnataka, principal sponsors of Jain art in this region in the tenth and eleventh centuries. The standing saviour carved out of black shale makes an impression with its polished rounded planes (cat. 63). The face has clearly articulated eyes staring straight ahead; the ears show lengthened lobes. While these features have been observed in earlier images of the Buddha, they are here infused with a static monumentality. The same immobility is seen in the imposing detached basalt head of a Jain saviour dating from the tenth century (cat. 64), as well as in the fourteenth-century bronze portrait of Parshvanatha (cat. 66). The latter figure is identified by

the cobra that coils up behind the body, spreading out its multi-head hood protectively over the saviour's head.

From the sixteenth century onwards the Arabian Sea coast of peninsular India attracted European traders, especially the Portuguese who made their headquarters in Goa. The Portuguese embarked upon an active programme of building churches and seminaries in an attempt to convert the local population to Christianity. Indian artists were employed to carve Christian images for worship, among them miniature ivory icons intended for private devotion (cat. 71). Though obviously based on European models, the image of the Christ child has the fleshy face and limbs typical of Indian sculpture. As in Buddhist and Hindu sacred icons, the figure gestures meaningfully to his worshipper.

Southern India

Hindu art traditions in southern India flourished from the seventh century AD onwards under a succession of kings governing independently in Tamil Nadu, Andhra Pradesh and Karnataka. Stone and metal sculptures fashioned in Tamil Nadu between the ninth and twelfth centuries under the Cholas are celebrated for their delicate modelling and poise. Chola art was also capable of a certain monumentality as apparent in the dignified ninth-century granite image of Vishnu (cat. 33). The god is dressed in a belted and tasselled costume, and wears a cylindrical crown on his head. A conch and disc are held in the rear two hands. An example of the Chola revivalist idiom promoted by the kings of Vijayanagara in the sixteenth century is the granite sculpture of a goddess (cat. 61). The two-armed figure is shown in a graceful triple-bent pose, holding a lotus in one hand. While the crown that she wears signifies her divinity, it is not certain whether she represents Devi, the consort of Shiva, or Lakshmi or Bhudevi, the companions of Vishnu.

Though also indebted to Chola prototypes, Vijayanagara period bronzes tend to be more fluid and refined, as in the majestic icon of Shiva as Nataraja dating from the sixteenth century (cat. 48). The god is shown with flying hair, vigorously pacing out the steps of cosmic

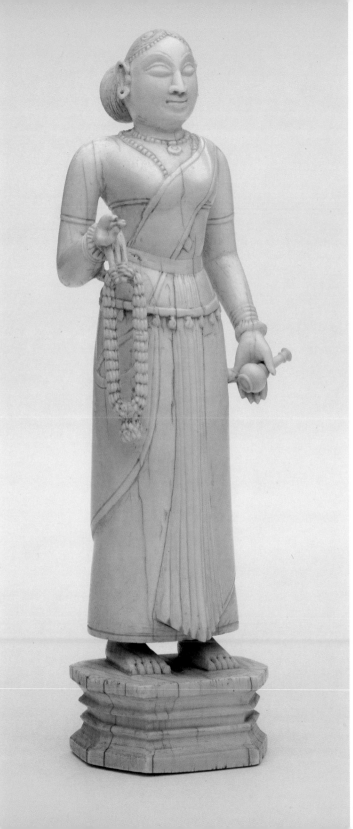
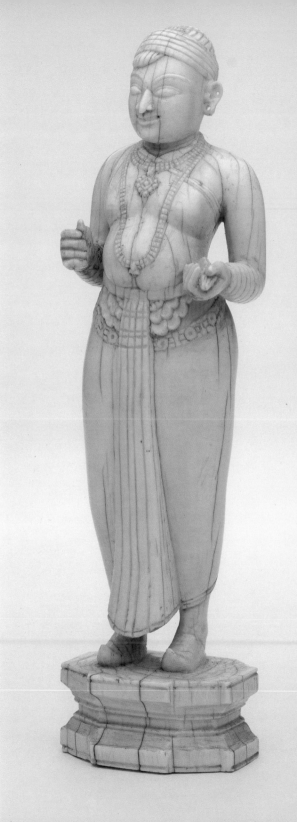

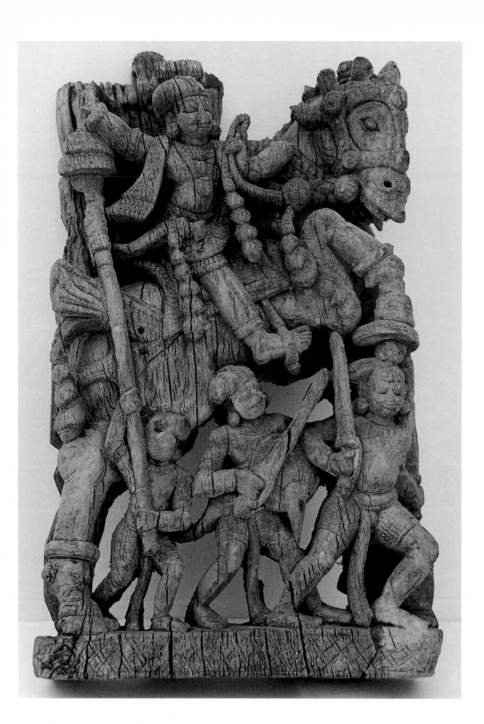

74 (left)
Warrior on leaping horse
southern India (Tamil Nadu)
18th–19th century
wooden chariot panels

69 (right)
Flying male warrior
central India (Madhya Pradesh)
Chandella period, 11th century
sandstone

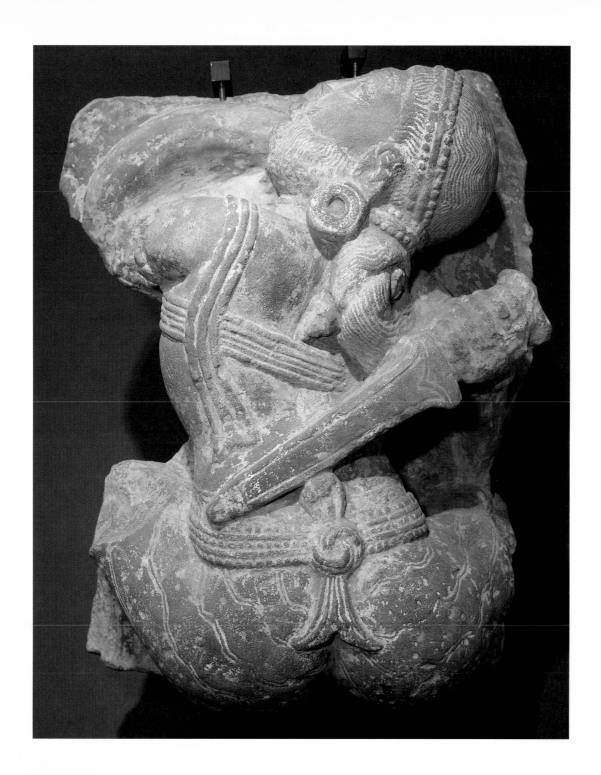

destruction. He is surrounded by a flaming aureole symbolizing universal order. With one foot he suppresses the dwarf of ignorance; the other foot is lifted high in an act of liberation. The facial expression, however, is calm. Nor is Shiva the only Hindu deity to be portrayed as a dancer. The youthful Krishna, too, paces out steps, in this case to quell the wicked cobra Kaliya (cat. 40). In the sixteenth-century bronze, Krishna places one foot firmly on the multi-headed hood of the cobra, while at the same time lifting up its tail with one hand. Other bronzes of the period are more static, as seen in the crowned Vishnu standing to attention, displaying flaming disc and conch in his rear two hands (cat. 39).

Hindu saints are also portrayed in southern Indian art. A sixteenth-century bronze of Manikkavachakar shows a curly headed youth wearing a simple loin cloth and holding a small book in one hand (cat. 49). More expressive is Ammaiyar, the female saint from the town of Karaikal (cat. 50). Ammaiyar sings songs of devotion to Vishnu, accompanying herself on small cymbals. The figure is remarkable for the skeletal limbs and sagging breasts; the eyes are open wide in ecstasy.

Wheeled chariots play an important role in temple festivals in southern India, transporting images of gods and goddesses through the streets of cities and towns. The wooden substructures of chariots, too, are cloaked in carved panels. Shiva appears as Bhikshatana, the naked ascetic with matted hair followed by a prancing dog, and in horrific form as Bhairava, shielded by snake hoods and accompanied by sages (cats. 53 and 52 respectively). These diminutive but lively compositions are characteristic of wooden art in the eighteenth and nineteenth centuries. A comparable exuberance is noticed in the pair of chariot panels showing armed warriors riding prancing horses (cats. 74 and 75). The dress and weapons of the figures and the apparel of the animals are rendered with precision. A similar naturalism animates the pair of seventeenth to eighteenth-century ivory figurines depicting a couple bearing offerings (cats. 72 and 73).

Kerala on the Arabian Sea coast of southern India is celebrated for its individual art traditions. Sculptures from Hindu temples in this region display a stylistic frenzy expressed in swirling

draperies and tassels, as in the painted wooden ceiling panel portraying Shiva as Bhairava (cat. 51). Deeply cut out of the supporting panel, the crowned figure holds a snake in one hand. The small bronze of Shiva disguised as a human hunter shows a two-armed warrior holding a bow and arrow (cat. 47). Metallic encrustations on the crown and costume are typical of Kerala metallic art.

Epilogue

The demand for votive icons of Hindu and Jain figures continues to keep Indian artists employed. Much of this image making activity, however, is essentially derivative and repetitive, in contrast to that of village traditions. Consider, for instance, the twentieth-century figurines of mothers with suckling infants produced in the Ghond tribal belt of Andhra Pradesh and Orissa (cats. 14 and 15). Created from superimposed coils of brass, these striking images may be compared with earlier terracotta 'mother goddesses' (cat. 2), thereby suggesting continuities in figural art over more than two thousand years.

Further Reading

Bridget Allchin and Raymond Allchin, 1982, *The Rise of Civilization in India and Pakistan*,
 Cambridge University Press, Cambridge
Carmel Berkson, 2000, *The Life of Form in Indian Sculpture*, Abhinav Publications, New Delhi
T. Richard Blurton, 1992, *Hindu Art*, British Museum Press, London
Pramod Chandra, 1985, *The Sculpture of India 3000 B.C.-1300 A.D.*, National Gallery of Art, Washington
Aschwin de Lippe, 1978, *Indian Medieval Sculpture*, North-Holland Publishing Company, Amsterdam and New York.
Vidya Dehejia, 1997, *Indian Art*, Phaidon Press, London
Devanagan Desai, 1975, *Erotic Sculpture of India. A Socio-Cultural Study*, Tata McGraw-Hill Publishing Co, New Delhi
J.C. Harle, 1986, *The Art and Architecture of the Indian Subcontinent*, Penguin Books, Harmondsworth
Susan L. Huntington, 1985, *The Art of Ancient India*, Weatherhill, New York and Tokyo
George Michell, 1989, *The Penguin Guide to the Monuments of India, Volume I: Buddhist, Jain, Hindu*, Viking, London
Pratapaditya Pal, 1994, *The Peaceful Liberators, Jain Art from India*, Los Angeles County Museum of Art/
 Thames and Hudson
David L. Snellgrove, (ed.), 1978, *The Image of the Buddha*, Vikas Publishing House/UNESCO, New Delhi

Glossary

avatara Incarnation of a deity, especially the Hindu god Vishnu, who appeared on earth in many forms, both animal and human, in each of the great cycles of time.

Bhairava 'The Terrible One', Shiva in his destructive aspect.

Bharata Natyashastra Fourth century AD treatise on dramaturgy; the earliest extant Indian work on aesthetics in the field of drama.

Bhudevi Earth goddess rescued by Vishnu.

Bhikshatana The Hindu god Shiva in the form of a naked ascetic with matted hair.

Bodhisattva In Mahayana Buddhism, a saintly and compassionate being who, having already attained nirvana, voluntarily renounces it in order to save mankind.

Brahma Maker of the universe. One of the principal Hindu gods sometimes considered to be a part of the Hindu Trinity with Vishnu and Shiva.

Buddha Siddhartha Gautama, the founder of Buddhism (c. 563-483 BC).

Buddhism Religion and philosophical system founded by Siddhartha Gautama, the Buddha or 'Enlightened One'.

chakra Cosmic disc or wheel.

Chamunda Hindu goddess of death (also known as **Kali**), one of the Saptamatrikas.

Chunda Jain goddess.

darshana Auspicious viewing of a deity within the temple, or outside at a public -festival.

dharma Moral law; man's ethical and religious duty and one of the four goals of life.

Gandhara Region forming part of present-day Afghanistan and north-western Pakistan.

Ganesha Elephant-headed deity associated with wisdom and good fortune who, as the Remover of Obstacles, is invoked before any undertaking.

Ganga Hindu goddess, personification of the Ganges river.

garbhagriha 'Womb chamber'; sanctuary, inner room of a temple.

Garuda Mythical figure - part bird, part man - identified with the sun; the vahana of Vishnu.

Hinduism Theistic religion without a formal creed, incorporating diverse beliefs and practices, including the cults of the gods Vishnu and Shiva.

Jainism A religion founded by Mahavira in the sixth century BC preaching a rigid asceticism and solicitude for all life as a means of escaping the cycle of transmigration.

jatakas 'Birth stories'; accounts of previous incarnations of the Buddha in either human or animal form.

Jina 'Conqueror'; a term applied to the Jain saviours - see **Tirthankara**.

Kali 'The Black', fearsome Hindu goddess of death and destruction.

Kaliya Multi-headed serpent king subdued by Krishna.

Karaikkal Ammaiyar Female ascetic, a devotee of Vishnu.

karma Law of cause and effect, according to which every action bears consequences either in this life or in future lives.

Krishna Popular Hindu deity; hero of the *Mahabharata* and revered as the eighth *avatara* of Vishnu. Worshipped in many forms, including the Divine Lover.

Kubera Guardian of the treasures of the earth (and therefore god of wealth); regent of the northern quarter.

Lakshmi Auspicious lotus goddess popular in Buddism, Jainism and Hinduism; the consort of Vishnu.

Mahabharata 'The Great Book of the Descendents of Bharata'; epic account of the civil war in the kingdom of the Kauruvas.

Mahayana 'Great Path'. A later theistic form of Buddhism, with emphasis on divine Buddhas and Bodhisattvas.

Maheshvara 'Great Lord'; name of Shiva

Manasa Protective snake goddess.

Manikkavachakkar Saintly Tamil poet, a youthful follower of Shiva.

Matrikas Mother goddesses.

mithuna Couple engaged in amorous embrace, found in temple art.

moksha Salvation; release from worldly existence or transmigration, the aim of all Hindu philosophy and one of the four goals of life.

mudra Gesture made by hands and fingers expressing a particular meaning, such as salvation, teaching or meditation.

Nandi Bull vehicle of Shiva.

Nataraja Shiva as Lord of the Dance.

nirvana In Buddhist philosophy, salvation; extinction of worldly desires and escape from transmigration.

Padmapani 'The Lotus Bearer', one of the principal Bodhisattvas.

Parshvanatha The twenty-third of the twenty-four Jain Tirthankaras.

Parvati 'Daughter of the Mountain', consort of Shiva, embodiment of peace and beauty.

prana Breath of life: a quality that animates all Indian sculpture.

Ramayana 'The Story of Rama', Hindu epic poem.

Rishabhadeva The first Jain Tirthankara.

rasa Essence or emotion; theory of beauty as experience.

Sarasvati Hindu river goddess identified with knowledge, music and the arts; the consort of Brahma.

shakti Power or force; active energetic aspect of a god.

Shilpashastras Texts giving detailed instructions for sculptors.

Shiva One of the principle Hindu deities: the great ascetic who is both creative and destructive.

stupa Hemispherical mound associated with Buddhism and Jainism; originally intended to enshrine relics of the great teachers.

Surasundari Beautiful maiden.

Surya Hindu sun god.

Tirthankaras Twenty-four saints whose teachings are the basis of the Jain religion.

tribhanga Triple-arched; pose of the three bends common in sculpture and in dance.

Uma Name for Parvati

Upanishads Sanskrit philosophical and mystical/metaphysical texts.

vahana Animal mount or 'vehicle' of a Hindu deity.

Vaikuntha 'The Penetrating One'; composite image of Vishnu combining human, lion and boar heads.

Varaha The boar, Vishnu's third incarnation.

Vedas Ancient religious books of the Aryans, the basis of later Hindu priestly rituals.

Vishnu One of the principal Hindu deities; his various *avataras* restore the balance of cosmic forces which sustains the universe.

yakshi Female nature spirit, associated with fertility and trees.

yoga Discipline that involves meditation and breath control.

yogi Hindu ascetic; literally one who practises *yoga*.

Chronology

2500–1500 BC	Indus Valley civilization flourishes; cities of Mohenjo-Daro and Harappa, on the Indus River (in present-day Pakistan).
2000–1000 BC	Aryan peoples arrive in several waves.
c.1500–500 BC	Vedic period; composition of the *Vedas*, India's earliest literary work, in the Sanskrit language.
c.800 BC	Iron age; spread of Aryan culture towards the east and the south.
563 BC	Siddhartha Gautama, the Buddha, founder of Buddhism is born; dies 483.
c.526 BC	Mahavira Jina, historical founder of Jainism, dies.
late 6th century BC	Persian king Darius conquers part of Pakistan.
327 BC	Macedonian king Alexander the Great reaches the Indus River.
321–187 BC	Maurya dynasty reigns in northern India; the earliest stone sculptures, with finely polished surfaces, date from this period.
c. 273–232 BC	Maurya emperor Ashoka reigns, embraces Buddhism.
4th century BC – 4th century AD	Composition of the *Ramayana* and the *Mahabharata*, India's two great Hindu epics and classics of Sanskrit literature; new religion of devotional theism (later known as Hinduism) begins to emerge.
2nd century BC – 5th century AD	Period of greatest Buddhist influence in India.
187 BC – 75 AD	Shunga dynasty in central India.
1st century BC – 1st century AD	Shakas invade subcontinent.
1st – 3rd centuries AD	Kushana dynasty reigns in northern India (at Mathura and in Gandhara in northern Pakistan and Afghanistan). Satavahana dynasty reigns in the Deccan; the first depictions of Buddhist, Jain and Hindu deities date from this time. The Gandhara region was an important meeting place of Indian and Mediterranean artistic traditions.
c.50 AD	According to tradition, the Christian apostle Thomas arrives on the Arabian Sea coast of India.
4th – 5th centuries	Gupta period in central India. Christian community of the Nestorian (Syrian) sect in existence at Cochin in Kerala.
late 5th century	Buddhist caves at Ajanta carved out and painted.
5th – 7th centuries	Popular cults of Hinduism flourish.
6th century	Hindu cave temple on Elephanta Island, near Mumbai (Bombay).
6th – 8th centuries	Pallava dynasty reigns in Tamil Nadu.
7th – 8th centuries	Buddhism begins to lose ground in northern India.

early 8th century	Arab merchants begin to settle on the coast of Sindh in Pakistan and Gujarat in India.
8th – 12th centuries	Palas rule Bihar and Bengal in eastern India. Ganga dynasty rules in Karnataka; many of these rulers converted to Jainism.
9th – 13th centuries	Chola dynasty becomes the dominant political force in the Tamil country in southern India; the Cholas were great patrons of Hindu art.
10th – 11th centuries	Chandella rulers of central India build numerous Hindu and Jain temples.
11th – 12th centuries	Chahamanas reigning in northern India.
11th – 12th centuries	Buddhism disappears in India.
11th – 13th centuries	Ganga rulers of Orissa build great temples at Puri and Konarak.
1192	Muslim conquest of Pakistan and northern India.
1206	First Muslim kingdom of India established at Delhi.
1336–1565	The Vijayanagara empire of south India battled against Muslim incursions for over two centuries, and maintained traditional Hindu cultural and artistic forms.
1510	Portuguese establish themselves in Goa on the Arabian Sea coast.
1556–1605	During the reign of Akbar, the Muslim Mughal empire includes all of northern India. Akbar's interest in religions leads him to commission the Persian translation (and the illustration) of the *Ramayana* and *Mahabharata*.
1631	Mughal emperor Shah Jahan begins building the Taj Mahal; expansion of the Mughal empire into the Deccan.
1641	The English East India Company sets up factories at Madras (Chennai).
1748	Collapse of the Mughal empire.
1858	Last Mughal emperor deposed by British.
1877	Queen Victoria crowned empress of India.
1885	The Indian National Congress is founded in Bombay (Mumbai).
1924–33	Excavations at Mohenjo-Daro and Harappa.
1947	Independence. The subcontinent is divided politically into India and Pakistan; the eastern part of Pakistan becomes Bangladesh in 1971.

List of Works

All dates are AD unless stated otherwise. Page references after titles refer to illustrations.

Auspicious females

1 **'Mother goddess'**
northern India
Maurya period, 3rd century BC
terracotta, h. 30.5 cm
Private collection

2 **'Mother goddess'** (p. 8)
northern Pakistan
2nd century BC
terracotta, h. 24.8 cm
*Victoria & Albert Museum,
London (IS 29-1939)*

3 **Head of a yakshi**
eastern India (West Bengal)
Shunga period
2nd-1st century BC
terracotta moulded plaque,
h. 22 cm
Private collection

4 **Mould with yakshi** (p. 14)
eastern India (West Bengal)
Shunga period
2nd-1st century BC
terracotta, h. 22 cm
*Anna Maria Rossi and Fabio
Rossi, London*

5 **Yakshi**
eastern India (West Bengal)
Shunga period
2nd-1st century BC
terracotta, h. 25 cm
Private collection

6 **Yakshi adjusting her necklace**
northern India (Uttar Pradesh)
Kushana period
2nd-3rd century
red sandstone, h. 78 cm
*Anna Maria Rossi and Fabio
Rossi, London*

7 **The goddess Sarasvati
playing a vina** (p. 17)
western India (Rajasthan?)
9th-10th century
marble, h. 43 cm
*Trustees of the National Museums
of Scotland, Edinburgh
(A1956.576)*

8 **Mithuna couples** (p. 51)
western India (Gujarat or
Rajasthan)
9th-10th century
sandstone frieze, 30 x 65 cm
*Courtesy of Marischal Museum,
University of Aberdeen
(ABDUA:64994)*

9 **Female torso** (p. 56)
western India (Rajasthan)
10th century
black chlorite, h. 28.5 cm
*Victoria & Albert Museum,
London (IS 45-1972)*

10 **Mithuna couple** (p. 16)
central India
(Madhya Pradesh)
10th-11th century
sandstone, h. 54 cm
*The British Museum, London
(1964.4-13.1)*

11 **Two surasundaris** (p. 12, 13)
central India
(Madhya Pradesh)
Chandella period,
10th-11th century
sandstone, h. 102 cm
Private collection

12 **Surasundari** (p. 15)
western India (Rajasthan)
11th century
marble, h. 108.5 cm
*Trustees of the National Museums
of Scotland, Edinburgh
(A1956.567)*

13 **Maiden** (p. 15)
eastern India (Orissa)
Ganga period, 12th-13th
century
sandstone, h. 65.5 cm
*The British Museum, London
(1872.7-1.93)*

14 and 15 **Mothers with
suckling babies**
Ghond tribal area (Andhra
Pradesh and Orissa)
20th century
brass, h. 16.5 cm and 13.5 cm
*Victoria & Albert Museum,
London (IS 51 and 52-1955)*

Buddhism

16 **Birth of the Buddha** (p. 22)
northern Pakistan (Gandhara)
Kushana period
2nd-3rd century
schist frieze,
h. 21 x w 46.1 cm
*Ipswich Borough Council Museums
& Galleries*

17 **Donor with casket** (p. 25)
northern Pakistan (Gandhara)
Kushana period
2nd-3rd century
sandstone, h. 82 cm
*Victoria & Albert Museum,
London (339-1907)*

18 **Head of the Buddha**
northern India (Uttar Pradesh)
Kushana period
2nd-3rd century
sandstone, h. 30 cm
Private collection

19 **Seated Buddha and
worshippers** (p. 24)
northern Pakistan (Gandhara)
Kushana period
2nd-3rd century
schist, h. 24 cm
*Courtesy of Marischal Museum,
University of Aberdeen
(ABDUA64996)*

20 **Seated Buddha with
worshippers**
northern Pakistan (Gandhara)
Kushana period
2nd-3rd century
schist frieze, h. 16 x w 41 cm
*Oriental Museum, University of
Durham (1952.1.13)*

41 **Praying Garuda**
southern India (Tamil Nadu)
17th century
wooden panel, h. 52 cm
Courtesy Gordon Reece Gallery,
London

The Pantheon of Shiva

41a **Torso of Shiva**
central India
Gupta period
5th-6th century
terracotta, h. 20.3 cm
Private Collection

42 **Fragment of Shiva dancing**
with an elephant (p. 43)
central India
(Madhya Pradesh)
10th century
beige sandstone, h. 55 cm
Anna Maria Rossi and Fabio
Rossi, London

43 **Ganesha and dancing**
mothers
central India
(Madhya Pradesh)
10th century
sandstone frieze
h. 47 x w. 73.7 cm
Trustees of the National Museums
of Scotland, Edinburgh
(A1970.261)

44 **Ganesha** (p. 7)
central India
(Madhya Pradesh)
10th-11th century
sandstone, h. 88 cm
The British Museum, London
(1872 7-1.62)

45 **Uma Maheshvara** (p. 42)
western India (Rajasthan)
11th century
marble, h. 74 cm
Trustees of the National Museums
of Scotland, Edinburgh
(A1956.570)

46 **Standing Shiva**
central India
(Madhya Pradesh)
11th century
sandstone, h. 67 cm
Anna Maria Rossi and Fabio
Rossi, London

47 **Shiva as the hunter** (p. 44)
southern India (Kerala)
16th century
bronze, h. 29.2 cm
Victoria & Albert Museum,
London (IS 43-1887)

48 **Shiva Nataraja** (p. 41)
southern India (Tamil Nadu)
Vijayanagara period,
16th century
bronze, h. 78 x 68.6 cm
Barber Institute of Fine Arts, The
University of Birmingham

49 **Manikkavachakar** (p. 45)
southern India (Tamil Nadu)
Vijayanagara period
16th-17th century
copper and lead, h. 55.6 cm
The British Museum, London
(1895.3-24.1)

50 **Karaikkal Ammaiyar** (p. 46)
southern India (Tamil Nadu)
18th-19th century
bronze, h. 25 cm
Victoria & Albert Museum,
London (IM 118-1924)

51 **Shiva as Bhairava**
southern India (Kerala)
18th-19th century
painted wooden ceiling panel
h. 38 x w 23.2 cm
Victoria & Albert Museum,
London (IS 2564C-1883)

52 **Shiva as Bhairava**
southern India (Tamil Nadu)
18th-19th century
wooden chariot panel,
h. 40 cm
Courtesy Gordon Reece Gallery,
London

53 **Shiva as Bhikshatana**
southern India (Tamil Nadu)
18th-19th century
carved teak chariot panel,
h. 70.3 cm
Victoria & Albert Museum,
London (IMI 46-1924)

Other deities

54 **Winged god** (p. 14)
eastern India (West Bengal)
Shunga period,
2nd-1st century BC
terracotta, h. 20 cm
Anna Maria Rossi and Fabio
Rossi, London

55 **Torso of Surya** (p. 52, 53)
central India
(Madhya Pradesh)
7th-8th century
sandstone, h. 76 cm
Private collection

56 **Head of Brahma** (p. 54)
central India
(Madhya Pradesh)
10th century
sandstone, h. 54 cm
The British Museum, London
(1880-8)

57 **Standing deity** (p. 55)
central India
(Madhya Pradesh)
Chandella period,
10th century
beige sandstone, h. 57 cm
Anna Maria Rossi and Fabio
Rossi, London

58 **Seated Kubera** (?) (p. 53)
central India
(Madhya Pradesh)
11th century
sandstone, h. 31 cm
Trustees of the National Museums
of Scotland, Edinburgh
(A1956.572)

59 **Surya** *(p. 57)*
eastern India
Pala period, 11th century
shale, h. 98.5 cm
Trustees of the National Museums
of Scotland, Edinburgh
(A1955.207)

60 **Manasa**
eastern India (West Bengal)
Pala period, 12th century
basalt, h. 63.8 cm
The British Museum, London
(1962.11-13.1)

61 **Goddess**
southern India (Tamil Nadu)
Vijayanagara,
15th-16th century
granite, h. 94.5 cm
Trustees of the National Museums
of Scotland, Edinburgh
(A1882.33)

Jainism

62 **Chunda, a Jain yakshi** *(p. 62)*
central India
(Madhya Pradesh)
11th century
sandstone, h. 109 cm
The British Museum, London
(1872.7-1.81)

63 **Standing Jain saviour** *(p. 65)*
Deccan (Karnataka)
Ganga period, 10th century
shale, h. 59 cm
Victoria & Albert Museum,
London (IS 502)

64 **Head of a Jain saviour**
(p. 66, 67)
Deccan (Karnataka)
Ganga period, 11th century
shale, h. 34 cm
Trustees of the National Museums
of Scotland, Edinburgh (A1905.4)

65 **Meditating Rishabhadeva**
(p. 64)
central India
(Madhya Pradesh)
Chandella period, 11th century
sandstone, h. 59 cm
The British Museum, London
(1872.7-1.98)

66 **Parshvanatha** *(p. 66)*
Deccan (Karnataka)
14th century
bronze, h. 35.9 cm
The British Museum, London
(1914.2-18.4)

67 **Chandrapabha**
western India (Rajasthan)
19th century
marble, h. 82.5 cm
Victoria & Albert Museum,
London (IM 3-1920)

Miscellaneous

68 **Male attendant** *(p. 17)*
western India (Rajasthan?)
9th-10th century
limestone, h. 49 cm
Trustees of the National Museums
of Scotland, Edinburgh
(A1970.262)

69 **Flying male warrior** *(p. 73)*
central India
(Madhya Pradesh)
Chandella period, 11th century
sandstone, h. 60 cm
Courtesy Gordon Reece Gallery,
London

70 **Seated figure**
central India
(Madhya Pradesh)
11th century
sandstone, h. 24 cm
The Oriental Museum, University
of Durham (1970.99)

71 **Christ child**
Goa
Portuguese period,
17th century
ivory, h. 17.2 cm
The British Museum, London
(1975.1-20.1)

72 and 73 **Male and female**
devotees *(p. 70)*
outhern India (Tamil Nadu)
17th-18th century
ivory, h. 22.7 cm (male)
and 21 cm (female)
The British Museum, London
(1878.11-1.331 and 332)

74 and 75 **Warriors on leaping**
horses *(74 p. 72)*
southern India (Tamil Nadu)
18th-19th century
wooden chariot panels,
h. 40 cm
Courtesy of Lynne Brindle

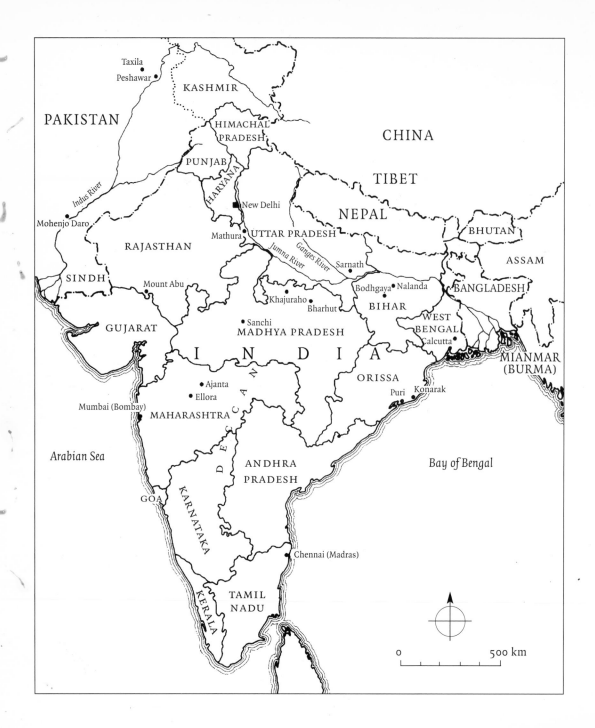